IMAGES
of America

HINCKLEY AND
THE FIRE OF 1894

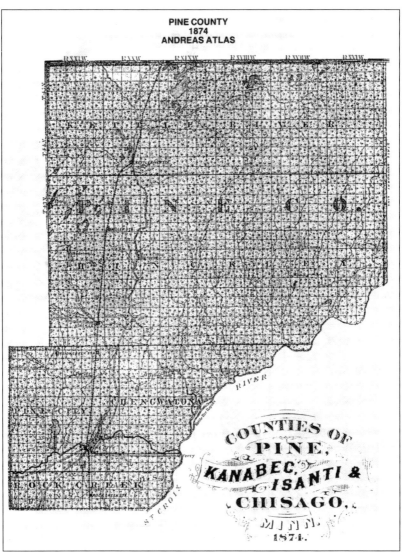

An 1874 map of Pine County illustrates how this area was completely covered by forests. What look like fuzzy dots are actually trees, the symbol for woodland. A few station stops are noted along the route of the Lake Superior and Mississippi Railroad, including Pine City, Mission Creek, Hinckley, Miller, and Kettle River. In another 20 years, three of these towns would disappear from the map on September 1, 1894. (Courtesy of Hinckley Fire Museum.)

ON THE COVER: Hinckley, Minnesota, organized a volunteer fire department in 1888. The members were proud of their new uniforms and Waterous fire engine. In 1892, the crew competed in a firefighting competition of all departments west of Chicago, Illinois, and earned a cash prize of $25 for second place. Fargo, North Dakota, beat Hinckley by 10 seconds on a 500-foot run to win first place. Members shown here are, from left to right, (first row) Frank Murray, J. Burke, Axel Hanson (perished in fire), Tom Connor, Pat Hogan, George Turgeon, Mike Lynch, Henry Hanson (perished in fire), Dennis Dunn, Tom Campbell, and John T. Clark; (second row) Ed Mitchell, R.J. Hawley, unidentified, John T. Craig, Dan McLaren, and J. Erhart. (Courtesy of Hinckley Fire Museum.)

IMAGES of America
HINCKLEY AND THE FIRE OF 1894

Alaina Wolter Lyseth
Foreword by Walt Tomascak

ARCADIA
PUBLISHING

Copyright © 2014 by Alaina Wolter Lyseth
ISBN 978-1-4671-1296-3

Published by Arcadia Publishing
Charleston, South Carolina

Printed in the United States of America

Library of Congress Control Number: 2014939171

For all general information, please contact Arcadia Publishing:
Telephone 843-853-2070
Fax 843-853-0044
E-mail sales@arcadiapublishing.com
For customer service and orders:
Toll-Free 1-888-313-2665

Visit us on the Internet at www.arcadiapublishing.com

This book is dedicated to my grandmother Walborg Mathilda Marie Rodeen Wolter, also known as "Wally." Her pursuit of knowledge was a daily adventure, her well-thumbed edition of Webster's dictionary always close at hand.

Contents

Foreword		6
Acknowledgments		7
Introduction		8
1.	Blazing the Trail	11
2.	Fleeing the Red Demon	21
3.	Firestorm	31
4.	Search and Rescue	41
5.	Rising from the Ashes	51
6.	New Kids on the Block	67
7.	No Ordinary Fire	91
8.	In Memoriam	107
9.	Everybody Comes from Somewhere	119

Foreword

Walt Tomascak grew up in Willow River, Minnesota, just outside the northern boundary of the Great Hinckley Fire. After graduating from the University of Minnesota with a forestry degree in 1963, he finished his career as a US Forest Service fire manager. He is still active as an operations section chief on a national interagency fire incident management team in the Northern Rockies Geographic Area.

In layman's terms, the Great Hinckley Fire was a firestorm—a rare occurrence in the history of forest fires. Like the 1910 fire in northern Idaho, and the Peshtigo and Cloquet fires in the lake states, it is strongly imprinted in the minds of fire managers. Truly, there are few forces in nature more destructive and terrifying than a forest fire violent enough to create its own weather. Even with the combination of eyewitness accounts and up-to-date knowledge of fire behavior, some aspects of this event remain a mystery. Here is what we do know.

Combustion consists of three components: fuel, oxygen, and heat. The fuels were in an extreme state because of the irresponsible logging practices being followed. The relative humidity was nine percent below normal that summer, and the rainfall total for July and August was less than two inches. The Hinckley area had four to five times more hot days than usual. All of this combined to cause a severe drought. Fire behavior also has three parts: fuel, topography, and weather. Fuel has already been established, and topography was a nonfactor. The real wild card was the weather, particularly the atmospheric conditions. Present that day was a temperature inversion. A warmer air mass was pressing down on a cooler air mass, trapping smoke and heat like a cap. Survivors have recorded that darkness came as early as noon that day, how they could not see their hands in front of their faces, and the unbearable heat. Also on that ill-fated day, two smaller but active fire events collided and created a blazing inferno at the southern boundary of Hinckley. This whirlwind of heat, flames, and gases exploded through the inversion cap. It resulted in the formation of a huge convection column, similar to a giant invisible chimney, sucking in air and oxygen from the outer edges, increasing in temperature, and moving at up to 10 miles an hour. Large chunks of burning debris would have been lofted great distances by this convection column, contributing to the rapid fire growth.

The superheated air was probably the biggest killer. Temperatures were in excess of 1,600 degrees Fahrenheit. Death from the radiant and convective heat would not have been as rapid. The fact that the fire grew so large and produced the extreme temperatures it did and then stopped its incredible spread rate after about four hours certainly points to some type of significant atmospheric event. Even modern fire behavior models may be unable to replicate the kind of fire activity that occurred on that September day.

—Walt Tomascak

Acknowledgments

For the encouragement to start (and finish) this collection of history, I wish to thank my mom, Sharon, and my dad, Al, who have lovingly demonstrated that being a parent is a job you never retire from. Thanks also to my Pine County history mentor Ron Nelson. I would like to give a shout-out to B.H. and Linda Von Rueden Troolin for the great research assistance.

The following organizations all contributed to my investigation: the Hinckley Fire Museum, Pine County Genealogical Society, Pine County Historical Society, Pine City Area History Association, and the Sandstone History and Art Center. My gratitude to the descendants of the fire victims and survivors who shared family photographs so that I could put a face on their stories of tragedy and triumph.

Unless otherwise noted, the images appear courtesy of the Hinckley Fire Museum.

INTRODUCTION

As a wall of flame erupted on the south side of Hinckley, Minnesota, panicked residents ran through the street shouting, "Run for your life!" Another screamed, "The depot's on fire!" Inside the St. Paul and Duluth station, 25-year-old telegrapher Tommy Dunn tapped out his final dots and dashes, "I think I have stayed too long," then ran for his life.

On September 1, 1894, residents of the bustling lumber town woke to the blast of the early morning steam whistle, which signaled the start of the first shift at the Brennan Lumber Mill. Shopkeepers opened their doors for early bird Saturday customers. The sunlight filtered through a red, smoky, eye-burning haze that came from the many small fires plaguing the area.

Conditions in east central Minnesota were ripe for a major fire. Much of Pine County was littered in tinder-dry pine slash from years of logging. Newspaper accounts of the time reported many small fires burning in the area. Makeshift fire crews had been battling blazes that threatened towns all along the tracks of the St. Paul & Duluth Railroad and the Eastern Minnesota Railroad. These two railways intersected at a point originally called Central Station, later renamed Hinckley.

A few miles south of Hinckley, near the villages of Mission Creek and Brook Park, two of these small fires, whipped by increasing winds, began their deadly run to the north. By 3:00 p.m., the fire by Brook Park had expanded to a three-mile-wide wall of flame. Residents had been planning to escape on a train scheduled to pass through on its way to St. Cloud. Unbeknownst to them, it had derailed just one mile before reaching their village. The intense heat had caused the tracks to warp and spread, overturning the locomotive. In desperation, many sought haven in the local millpond.

Simultaneously, six miles to the east, a large fire burned near Mission Creek. The skies turned black as midnight when the fire, pushed by gale-force winds, overwhelmed the town. Most of the citizens ran for a potato patch and covered themselves with wet blankets.

As the afternoon warmed and the winds increased, these two fires raced towards Hinckley. Updrafts, created by 1,500-degree (Fahrenheit) heat, carried sparks and firebrands high in the air, where strong winds carried them far ahead of the fire front, starting hundreds of smaller fires. This leapfrogging effect resulted in an explosive rate of spread.

The two fires converged just south of Hinckley, where the volunteer fire department battled valiantly but hopelessly against the onrushing flames. As buildings literally began exploding around them, fire chief John T. Craig ordered his men to save themselves and their families. The local Catholic priest, Father Lawler, rushed through town shouting, "For heaven's sake, leave all you have, Hinckley will be destroyed!"

Located next to the Eastern Minnesota depot was a spring-fed gravel pit that had long been considered by locals as a blight on the landscape. Even on that hot, droughty, summer day, it still held about three feet of water and animals continued to use it as a watering hole. In retrospect, the entire population of the town could have been saved in its shallow depths. But,

panic caused some to run north of town, many jammed onto the waiting trains, and only about a hundred people dashed for the gravel pit.

Waiting on the Eastern Minnesota siding that day was the "Daily Freight" No. 24 with Edward Barry in engine No. 105. It had been delayed on its southbound run from Superior, Wisconsin, to Hinckley after encountering dense smoke along its route. Finally arriving at the station, Barry was unable to reach the roundhouse to turn around because the rails were contorted from the intense heat. Barry was forced to pull his train onto the siding because of the expected arrival of another train from Duluth, which had the right-of-way. Passenger train No. 4, driven by William Best in engine No. 125, pulled in over two hours behind schedule due to the same low visibility conditions Barry had met. After a hurried conference, the two engineers decided to couple their trains together for an emergency return trip to Duluth. This decision meant that both engineers would have to drive backwards because the roundhouse was inaccessible.

The trains caught fire as they headed north out of town. This did not deter Best from stopping to pick up an additional 40 refugees along his route. He then gambled on crossing the burning trestle over the Kettle River. Only minutes after creeping across the bridge at five miles per hour, the structure crashed into the river 150 feet below.

Sandstone was one of the six towns incinerated in the fire. Most of its residents, as in other towns, did not heed the repeated warnings to leave. Those who saved themselves managed to do so by reaching the Kettle River. Many perished as they ran towards the river.

While this drama was occurring, another tragedy was taking place on the northern outskirts of Hinckley. Death overcame 127 souls and countless animals huddled in a marshy area along the railroad tracks instantly when a fireball rolled overhead, sucking the air from the lungs of man and beast. Witnesses reported hearing one loud moan, then silence.

Back in Hinckley, Tommy Dunn was still at his post in the St. Paul & Duluth depot. He received the unbelievable message that the town of Brook Park was annihilated, along with possible loss of life. He was still reluctant to leave his telegraph key because the southbound "Limited" passenger train was due and he wanted to warn engineer James Root at the throttle of engine No. 69. Mentioned earlier, Dunn believed he waited too long, and he had. The next day his body was discovered by the Grindstone River and identified by his father.

As events unfolded, Root's "Limited" No. 4 was stopped one mile north of Hinckley by fleeing residents who warned him not to continue. After boarding 150 or so refugees, Root put his engine in reverse and drove backwards for six miles. Although fainting and being revived twice, he was able to navigate his burning train, now filled with 300 injured passengers, to the lifesaving swampy waters of Skunk Lake.

The flaming inferno continued its northward trek, destroying the small communities of Miller and Partridge and damaging regions of Finlayson and Hell's Gate, gradually losing its destructive force after four hours of uncontrollable fury.

The death toll of Native Americans was impossible to calculate. It is known that Ojibway chief Wacouta and 23 of what was assumed to be his band were found in a 10-mile radius of their autumn hunting camp.

Living through what could be called the most devastating forest fire in history, survivors shared blankets, food, water, and shelter through the long, cold night of September 1. The next day, surrounding towns and larger cities like Duluth and Superior, Minneapolis and St. Paul, and St. Cloud began organizing relief efforts. Food, water, doctors, and medical supplies were needed immediately, as were tents for shelter. Three days after the fire, Minnesota governor Knute Nelson appointed a state relief commission to coordinate the collection and disbursement of supplies and money. News of the holocaust at Hinckley was soon telegraphed around the globe. In addition to the mountains of supplies that came rolling in from around Minnesota and the nation, just under $100,000 in cash donations were received. Foreign nations contributed $12,000 of this total. Duluth alone provided shelter and aid to 1,200 survivors. Railroads across the United States offered free transportation of needed supplies. Massive search efforts were soon underway for survivors and victims of the fire. County coroner D.W. Cowan

was charged with the herculean task of identifying bodies and compiling an official death list, which totaled 413 when he filed his report on November 24, 1894. This figure included 99 unidentified victims. Bodies continued to be found intermittently for the next four years, adding to the gruesome total.

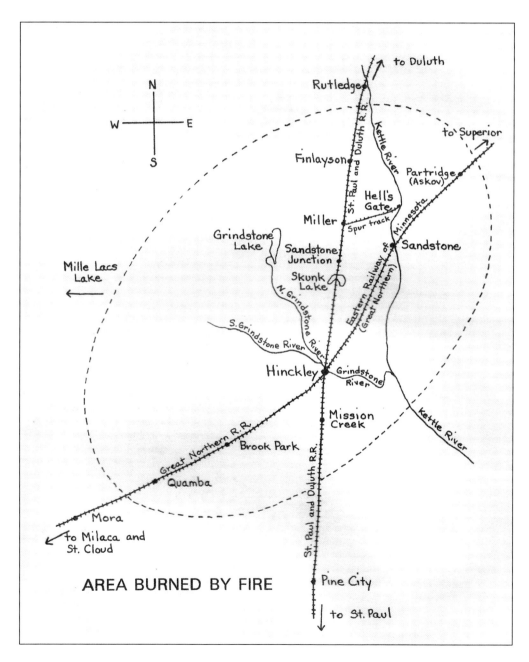

One

Blazing the Trail

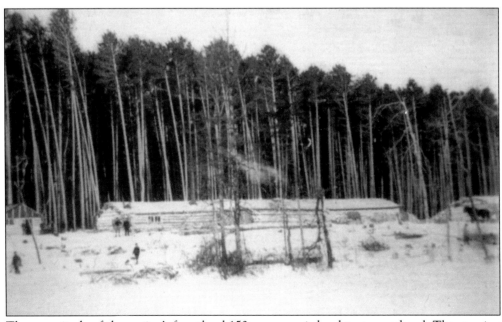

The magnitude of the nation's forestland 150 years ago is hard to comprehend. The growing country considered the white pine tree to be an inexhaustible resource. The trees shown here are over 100 feet tall and, as a logger would say, "dog hair thick."

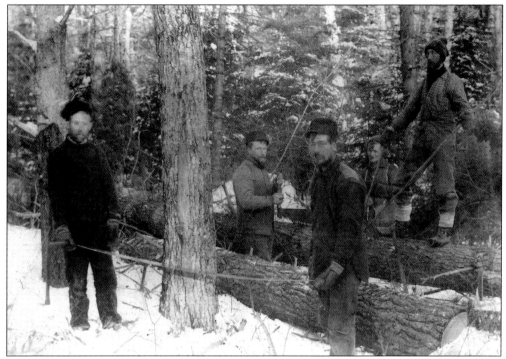

Logging season commenced in the northern pineries in late fall. Once lumberjacks felled the trees, swampers hacked off the tops and branches. The jacks then cut the tree into lengths. Skidders would attach specialized tongs, which were linked to horses or oxen. This team would drag it out to a central point called a landing. (Both courtesy of Ed Ness.)

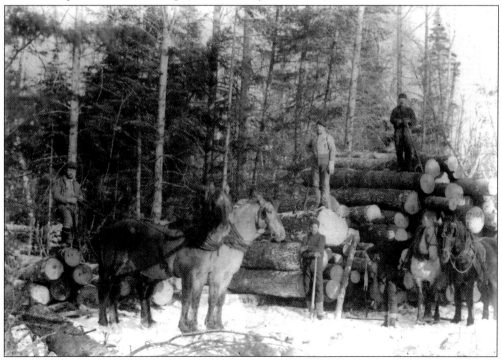

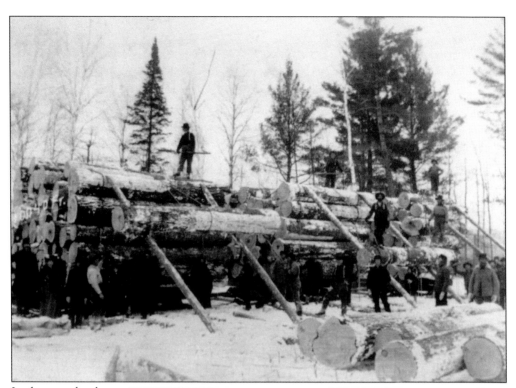

In the cross-haul method, a pair of poles were leaned against the sleigh, a log was maneuvered into position by the cant hook men, and a chain was wrapped around its middle. The other end of the chain was hitched to a horse on the opposite side of the sleigh. As the horse pulled, loaders on the ground would guide the log as it rolled onto the sleigh. The top loader had the dangerous job of stacking, balancing, and securing the load.

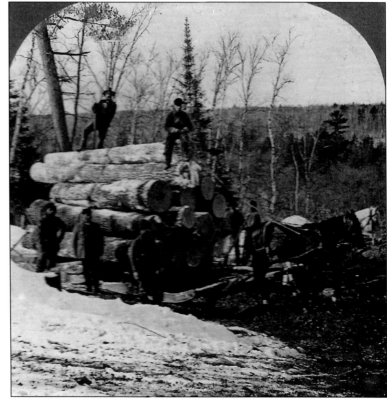

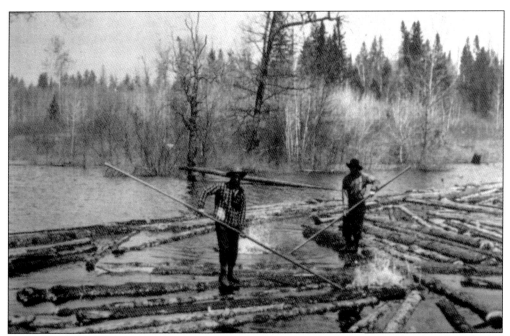

Rivers were the nation's earliest highways. The sleighs were unloaded on a riverbank and stockpiled there until springtime, when they were pushed into the rushing meltwater, which carried them downstream until eventually reaching a sawmill. The men shown here are helping guide the logs to their destination.

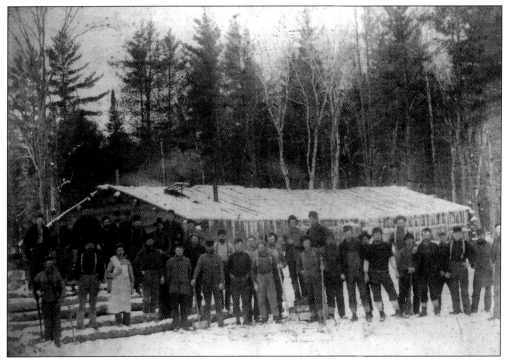

The logging crews were housed in a central, low-roofed cabin during the winter. This is where they spent all of their nonworking hours. (Courtesy of Ed Ness.)

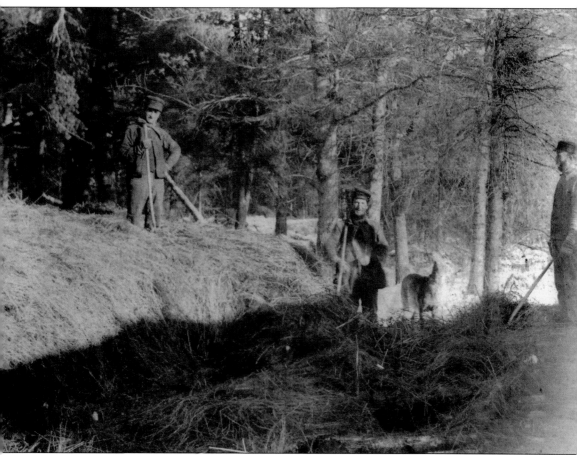

All of that horsepower had to be kept fed during the winter working months. Logging companies had a crew that worked all summer to put up hay for their horses and oxen. The hay pile shown here is also attracting a hungry deer, no doubt a camp pet. (Courtesy of Ed Ness.)

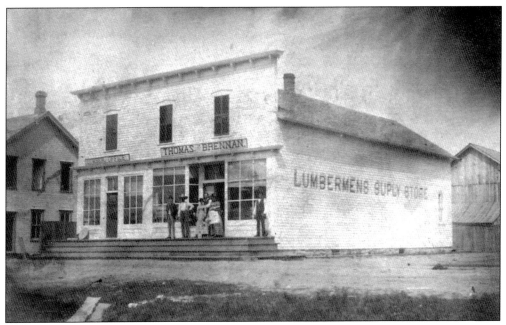

This structure housed the Brennan Lumber Company office and its mercantile. The inventory boasted any item a pioneer—male or female—would need to carve a living from the pineries of east central Minnesota. In August 1894, manager Walter Scott advertised an exclusive line of dress goods, clothing, and groceries. Prices on closeouts included children's fine shoes for 20¢ a pair, driving shoes for $1.75, and ladies' underwear at 50¢ on the dollar.

The Brennan Lumber Company was the major employer in the early days of Hinckley. In April 1894, the sawing commenced for the season. The *Hinckley Enterprise* reported that 225 men would soon be on the payroll, and coin of the realm would be circulating somewhat livelier among the town's merchants. The sawmill paid common laborers $1 a day, while skilled workers earned about $4 a day. (Courtesy of the Pine County Historical Society.)

The James Anthony Jordan family is featured in this photograph, taken around the time of the fire. Posing here are, from left to right, James, unidentified, James's children Tom, Jim, and Mary, unidentified, James's other child Grace, and his wife, Cora. On the day of the fire, Cora was at home sewing, while James and one of his sons were out picking cranberries. As the skies took on unnatural midday darkness, James hurried home and hustled his family aboard the Eastern Minnesota train. Deciding to run home for his wallet, he returned to an empty depot. The old lumberjack headed for a nearby bend in the Grindstone River, where annual log drives had scoured out a hole under the bank. By alternately running while holding his breath, then dropping to the ground to breathe, he avoided inhaling the lung-damaging heat and toxic gases. Even though his shirt and pants were burned off, Jordan reached the protection of the overhang and survived for over four hours until the inferno had passed. He often repeated the tale, saying that the only thing that saved him was his heavy woolen suit of underwear and his wide-brimmed hat. The proud homeowner of this rustic shanty has beautified it with lace curtains, and the home even displays a house number. (Courtesy of the Jordan family.)

The Fourth of July was a grand celebration in Sandstone in 1888. This locomotive is proudly flying the American flag, which displayed only 38 stars at the time.

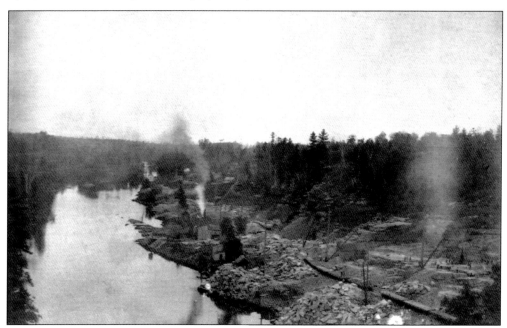

The village of Sandstone was located on top of a bluff overlooking its namesake quarry, which was established on the banks of the Kettle River. This operation was a major employer in the area, swelling the town's population by hundreds when extra manpower was required to fill a large order. As the firestorm roared into town, many residents saved their lives in the water seen here, probably photographed from the railroad bridge just north of the quarry.

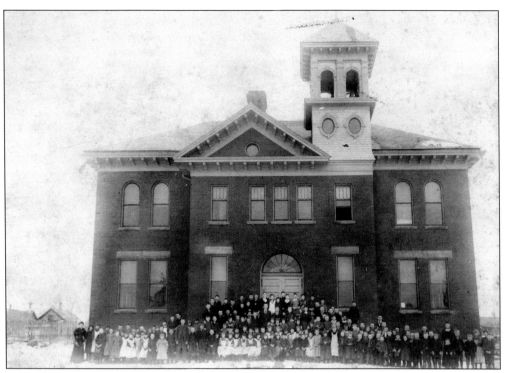

The town of Hinckley prospered in its first 20-plus years of existence. By 1893, the population had increased enough to support the construction of an impressive four-room brick schoolhouse. The doors opened for the first time that autumn, and when school resumed after the winter break in January 1894, the class roll counted 154 pupils. Professor Collins held the duties of principal. Misses Craig, Hawley, and Vaughan were in charge of the other departments. Just days before school was due to start for its second year, the handsome new building was reduced to a skeleton of blackened bricks. All of the school's records were destroyed.

Unaware of what the future held for them in Hinckley, Minnesota, Lydia Adams Tongue Dethick (right) playfully posed with her second husband, William Dethick, daughters Kate and Jane, and granddaughter Lizzie Tew. This photograph was taken in England around 1883.

Catholic parishioners in Hinckley built their first church in 1879 (far left). Just two weeks before the fire, villagers attended a lawn social sponsored by the church ladies. An excellent spread was served, and music was rendered by the Presbyterian choir and others. When parish buildings were consumed by flames soon thereafter, a new spire was pointing heavenward by 1895 (center). The present brick edifice was constructed in 1951 (far right), and the 1967 tower includes a bell that lay amid the ruins on September 1.

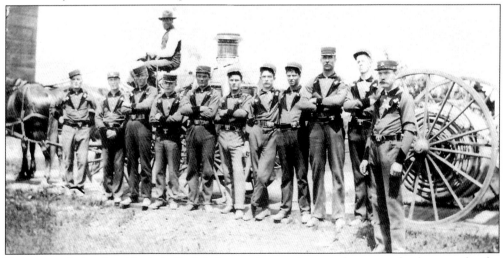

Posing nonchalantly with their firefighting equipment is an early group of volunteers for the Hinckley Fire Department. In the last issue of the *Hinckley Enterprise*, printed the week before the tragedy, editor Angus Hay expressed the public's gratitude for their service. The men had just presented the village with a shiny new hose cart, fabricated by Dan McLaren and other mechanics at the local blacksmith shop. The fire laddies are, from left to right, John Stanchfield, Dennis Dunn, John Andrews, Louis Wirfes, Dennis Brennan, Wilfred Currier, Bolivar Stanchfield, Frank Norton, John K. Anderson, Swan Andrews, and Will Russell. Ole Dean is driving the wagon.

Two

FLEEING THE RED DEMON

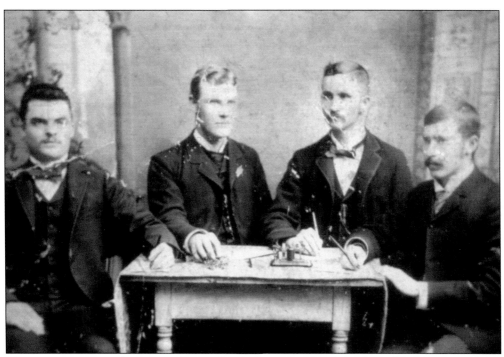

These young men may have recently completed telegraphy school. A telegrapher was an important occupation in the early days of railroading. Operators stationed at each depot used Morse code to communicate train movements and schedules. Their job can be compared to a modern-day air-traffic controller. Charles Collins (left), a depot agent in Hinckley, later married fire survivor Mayme Brady.

A career with the railroad brought Joseph and Patronella Williams to Hinckley in 1888. That summer day in 1894 found them, and most residents of the town, dismissing the warning signs from the thickening smoke and rising temperature. As the danger became imminent, they joined the neighboring Tew family on their wagon and headed east, away from the approaching sea of flames. Desperately holding on, they arrived at the tracks of the Eastern Minnesota Railroad and began crowding into a passenger car. Drayman Joe Tew, daughter Lizzie, and her Grandma Dethick selflessly gave up their opportunity to escape on the train and managed to survive in the Grindstone River. The entire Williams family was rescued and endured a perilous ride to Duluth. Upon returning to the ashes of their home, they found a religious picture that was completely unscathed. One of the few families that carried property insurance, the Williamses received a payment of $300 and rebuilt their home in Hinckley. Pictured from left to right are (standing in front of the fence) Dora, Irene (born after the fire), Nell, Elizabeth, John, and Conrad; (standing behind the fence) Joe, Patronella, and Mary. (Courtesy of Helen Lynch Peterson family.)

This Ojibwe woman was 22 years old when the firestorm swept down upon the shores of Grindstone Lake. Mah-kah-day-gwon (Blackfeather) heard the cries of Mary Ellen Patrick and her two young sons. Their boat was being blown around the lake by the swirling winds. She put her own two children in a canoe and paddled out to rescue the family. That evening, she gave them food and shelter, even sewing a pair of moccasins for Roy Patrick, who had lost his shoes.

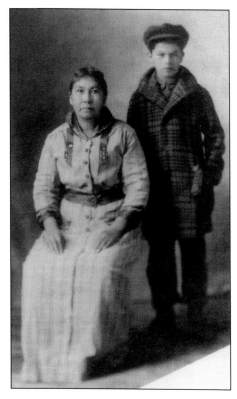

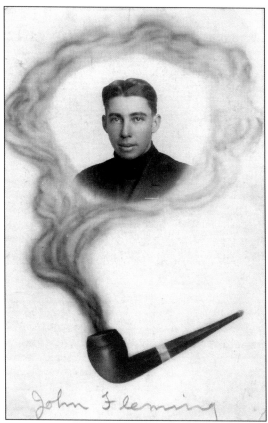

The parents of John Fleming were living in Hinckley with their seven-week-old infant. James and Mary Brennan Fleming fled to the Eastern Minnesota train and made their getaway. When the train reached Superior, Wisconsin, its townspeople wanted the refugees to disembark so they could give them aid and comfort; however, Duluthians insisted the homeless should rightfully be assisted by them. This most desolate journey ended on the Minnesota side of Lake Superior.

Returning home to an empty house, John Nels Tenquist (pictured here with his wife, Helena) saved himself and a Singer sewing machine in the gravel pit. At his ruined homestead the next day, there was the family cow, bellowing where the barn used to be and not a singed hair on her. Then, two days later, Tenquist received word that his family was among the refugees in Duluth. Later generations operated the Tenquist Trading Post in Hinckley. (Courtesy of the Tenquist family.)

A very pregnant Helena Tenquist was at home in Hinckley on the day of the fire. Her husband, John, was at work in the nearby rail yard. As the flames raged closer, she grabbed young sons Elmer, Carl, and Bert and joined the hysterical throng that fled the flames on the Eastern Minnesota Railroad. Shown here are, from left to right, Helena, son Ed, granddaughter Alfa, and daughter Mary Adele, born in Duluth 18 days after the fire.

A section of the death list (at right) reveals that victims nos. 172, 173, 174, and 175 were members of John McNamara's family. They had all run north of Hinckley and joined the crowd riding backwards on the burning train that stopped at Skunk Lake. Here, the McNamaras jumped off and continued running up the tracks. The family became separated in the smoky darkness, and late that evening a rescue crew found several bodies north of Skunk Lake, one of which was lying on top of a black purse (below). The leather handbag contained $3,500 in cash and certificates of deposit. An astonished John McNamara identified his wife Annie's purse, unaware that she had been saving for their sons' higher education. John Jr. was to have left the next day for school in St. Paul but instead was buried with his mother and brothers. (Below, courtesy of Al Wolter.)

MINNESOTA FOREST FIRES. 111

163. Martinson, ———Age 2 months, daughter of M. Martinson; found with mother in the river.
164. Murphy, Mike—Age 40, husband of Mrs. Nancy Murphy, of St. Paul; residence, Hinckley; was not found; supposed to have been burned in the mill yard at Hinckley.
165. McDonnell, John—Age 27, married; residence, Hinckley; was seen to go over the railroad bridge with others; none returned; was not identified; has father, Jas. McDonnell, in Wauzeka, Wis.
166. McDonell, Bertha—Age 27, was seen to cross St. P. & D. Ry. bridge, with her husband; was not identified; reported by Michael Dunn.
167. Molander, Fred—Age 25, married; found in well near his house.
168. Molander, Mrs.—Age 25, wife of Fred Molander; found in her house; identified by proximity to her house, and having children in her arms.
169. Molander, ———Age 3, daughter of Fred Molander.
170. Molander, ———Age 1, son of Fred Molander; identified by A. Berg.
171. Mattison, Hans W.—Age 20, single, burned in swamp one-half mile north of Hinckley; not identified; has parents living in Eau Claire, Wis.
172. McNamara, Mrs.—Age 48, wife of John McNamara of Rutledge; found on railroad track, north of Hinckley; identified, and buried at Hinckley.
173. McNamara, John—Age 14, son of Mrs. McNamara; found on track with his mother.
174. McNamara, James—Age 12, son of Mrs. McNamara; found and buried with his mother.
175. McNamara, Michael—Age 8, son of Mrs. McNamara; found and buried with his mother.
176. Nelson, Mrs. Betsy—Age 42, married, wife of Nels Nelson; residence, Hinckley; not found; burned in swamp one-half mile north of Hinckley; reported by her husband.
177. Nyberg, Maggie—Age 20; residence, Hinckley; not identified; has relatives in North Branch, Minn.; reported by B. C. Bartlett.

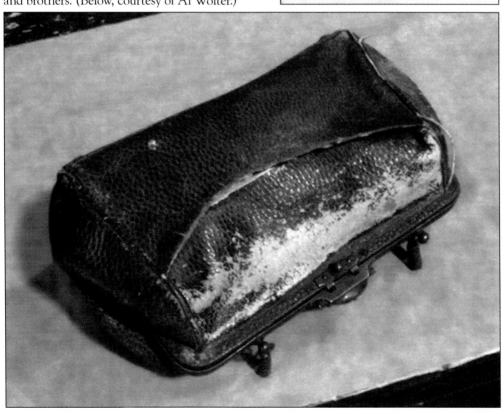

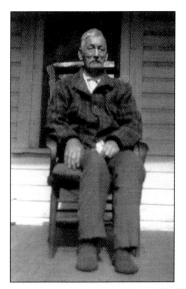
This contented-looking man is James Anthony Jordan, a Pine County pioneer and fire survivor. His life tells the tale of a man who stood firm and settled the burned-over district twice. He came to Hinckley in 1882 and relocated in Sandstone after the fire. In addition to farming and logging, he was a landscaper, telephone lineman, Christmas-tree salesman, and moonshiner. He transported bodies for the undertaker and hauled water to settlers who did not have a well. Jordan could earn $8 a day on wash days. But, his claim to fame was making axe handles. Customers, including logging camps and the Sandstone quarry, paid $1 for six handles or $2 for a dozen. Jordan boasted that he could hew a wagon full of black ash handles in a day. At age 76, Jordan was imprisoned for a crime he said he was innocent of committing. The sturdy old man refused to let his family pay the fine that would have assured his release. He steadfastly served his sentence, passing away two years later, in 1930. (Courtesy of the Jordan family.)

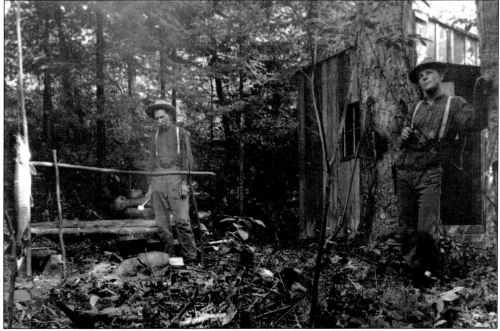
Bill Grissinger Jr. (right) was nine years old when the firestorm devoured Hinckley. His father, Bill Sr. (left), had just left on a two-day trip. As the situation in town became perilous, the local housewives decided to escape with their children on the train. After changing clothes, they all headed for the St. Paul and Duluth Railroad depot. Balls of fiery gas began exploding overhead as they realized the train was not there. Mrs. Grissinger directed Bill Jr. and his two sisters to run north on the tracks. The path they chose was littered with bundles and satchels discarded by fleeing townspeople. Blinded by smoke, young Bill came alongside Jim Root's reversing "Limited" and leaped for the handrail. When it stopped at Skunk Lake, he jumped off into the swamp. Freezing cold and covered with mud, he endured the night with 300 other passengers. Later, the list of dead and missing included his mother and sisters Mabel and Callie. The Grissinger men are pictured at their cabin in the 1920s. Note the stringer on the left displaying their catch of the day.

Siblings John Williams, below, and Mary Williams, at right (on the left), escaped the inferno in Hinckley. He was two years old when his mother, Patronella, carried him to safety aboard the Eastern Minnesota train. He later survived World War I battlefields in France and received a Purple Heart with an oak leaf cluster. Mary attended convent school before returning home after her mother's death. She spent the last three years of her life running her father's household before an early death at age 27 from Bright's disease. Also shown at right are their sister Lucille and Barney the dog. (At right, courtesy of Linda Troolin; below, Lyn Degelbeck.)

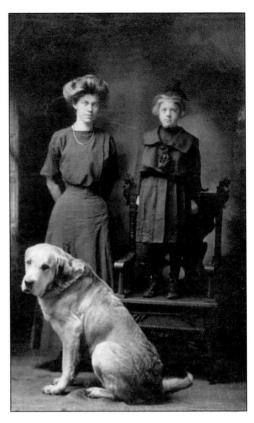

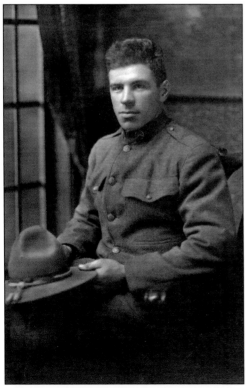

Shortly before his death in 1928, Joe Tew traveled to his ancestral home, the Mill House Farm in Cheadle, Staffordshire, England. In Hinckley, he was known as the local drayman. On the fateful day, he loaded the Williams and Vander Beek families, along with his own clan of nine, onto his wagon and drove them to the Eastern Minnesota Railroad depot. In the mass confusion there, his three-year-old daughter, Alice, was almost left behind. Joe's wife, Jane, had protectively wrapped the child in her shawl and set her on a bench. Alice's uncle Ed Mitchell happened by and recognized the garment, picked it up, and was surprised to find his young niece enclosed in the folds. As Joe Tew was unable to find space on the boxcar for his eldest daughter Lizzie, his disabled mother-in-law, and himself, they raced the wagon to the Grindstone River and found sanctuary from the flames. The next day, his hardworking team of horses was found dead nearby, but a bawling pet calf survived in the water with them. Tew was elected the first mayor of Hinckley after the fire. In this photograph, he and Jane are the couple on the right. (Courtesy of Doreen Axell.)

As word spread that the town was doomed, Dunn family members gathered to discuss a means of escape. Patriarch Michael Dunn was working near the St. Paul and Duluth Railroad water tank. Brother Thomas Dunn returned to his post at the telegraph office. Sister Mary Dunn McIver and her family escaped on the Eastern Minnesota train. Sister Bertha Dunn McDonnell (pictured) and her husband, John, made the decision to run north on the wagon road. They were never seen again.

A month after Hinckley was decimated, infant George Tew (pictured) returned home with his family. On the afternoon of their return to town, George died from effects of the fire. His nine-year-old sister, Mary, passed away the following February, also from lingering effects of the fire. On display at the Hinckley Fire Museum is a petite China doll that she carried on the train that day, a silent tribute to her young life. (Courtesy of Roberta Johnson.)

The toddler being held in the center of this group is Lester Samuel Scott, born in Duluth three weeks after his mother survived the Great Hinckley Fire. The Scott family members shown here are, from left to right, (first row) Catherine Scott Smith, Margaret Scott, Lester, Walter Scott, and Anna Hawley Scott; (second row) Mary Hawley Scott, Samuel Scott, and John Hawley. (Courtesy of Annie Marczak.)

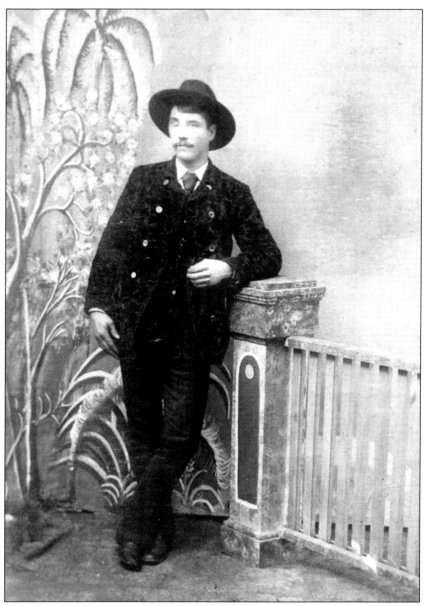

As a young child, Maurice Francis Stanchfield was playing with a corset stay and snapped himself in the eye. Complications set in, resulting in total blindness. "Blind Frank" was 12 years old and living with his mother, Cora, and adoptive father, James Jordan, in Hinckley on the first day of September 1894. As scorching flames reached out and hot gases exploded around him, Maurice somehow made it to the Eastern Minnesota Railroad depot with his mother and five younger siblings and escaped the "red demon." Maurice became self-reliant and independent, earning money by tuning pianos. He moved to the Twin Cities and became an advocate for the needs of the adult blind in Minnesota. He was instrumental in passing legislation that set up a state department for the blind. In 1922, marriage to Delcie Smith (also sightless) gave Maurice an active partner as they worked to prove that industry, thrift, and intelligence would bring success to the blind just as it would the sighted. Maurice died from a heart attack at the age of 49. (Courtesy of the Jordan family.)

Three

FIRESTORM

Swedish cabinetmaker Martin G. Martinson had found steady work in nearby Rutledge. He commuted 18 miles north on a weekly basis, returning home to Hinckley on the weekend. That fateful Saturday, the depot agent mentioned rumors of a large forest fire. The family man quickly boarded a southbound train, which traveled as far as Skunk Lake. Jim Root's engine No. 69 was blocking the rails. A search of the nearby swamp revealed none of his family. He covered his face with a handkerchief and stumbled five miles along the tracks until he reached the smoking ruins of his home. He located the bodies of his wife, Inga, holding their infant, drowned in the Grindstone River. Nearby were his dead daughters Ida, Emma, and Hilda. His 11-year-old son, Johan, had become separated from his mother and sisters, saving himself in the gravel pit. While father and son were digging a final resting place for their loved ones, Martin stumbled upon a scorched Bible written in his native tongue. This tome, shown here, became a symbol of hope for the two men.

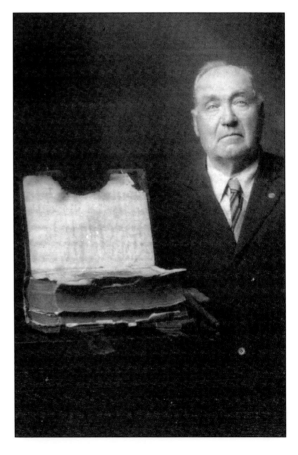

This lady was only nine years old when a wall of flames swept through the settlement of Mission Creek. Jennie Johnson's father set her in a rocking chair in the middle of a potato patch and covered her and her doll with wet blankets. Jennie Johnson survived, along with her doll and chair, which are on display at the Hinckley Fire Museum. (Courtesy of Earl Jackson.)

Lydia Tew, 10 years old in 1894, always remembered the terrifying despair she felt when there was not room in the boxcar for her father and sister. But, the entire family was reunited three weeks later. The Hinckley Fire Survivors' Association was a group that met every September to remember the victims. Tew's obituary proudly states that she attended all 70 annual meetings until the group was dissolved in 1964. (Courtesy of Doreen Axell.)

Hinckley volunteer fireman Henry Hanson (at right) became a number on the list of the known dead after that day. He gathered his wife and six children and helped them board the Eastern Minnesota train. Returning to the village, he guided another group of people to the still-waiting train. Hanson went back a third time and was never seen alive again. The next day, scorched remains were identified in the swamp north of town by fellow fireman J.K. Anderson, who recognized Hanson's snuffbox lying next to the body, completely unharmed. Hanson's widow, Emma, and six children (below) returned to live in Hinckley and built a new home on their previous lot. She took in boarders to provide an income. In 1896, she married John Lundberg in a double ceremony with her sister Ella Klint and Frank Wirfs.

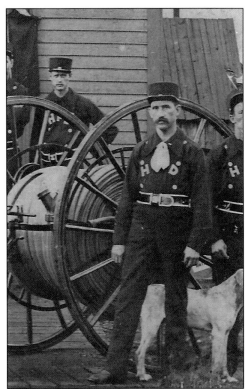

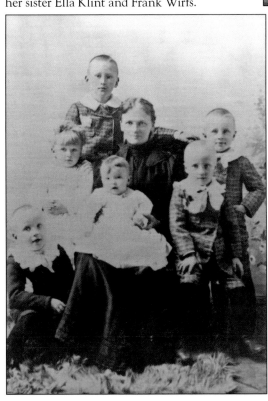

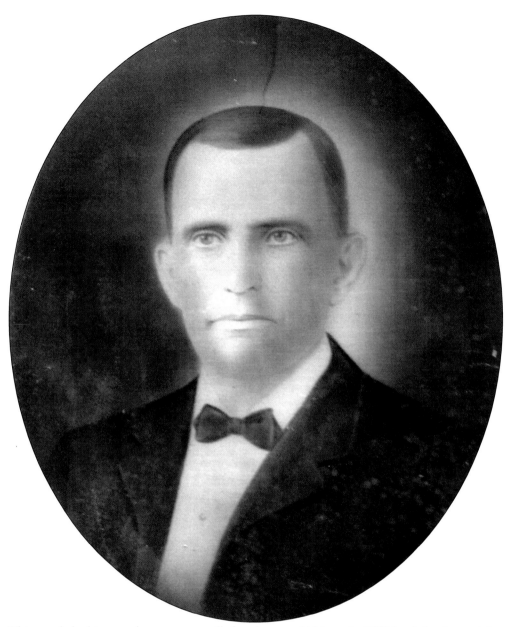

This stately looking gentleman was enrolled at the age of 14 into the US Naval Academy. After withdrawing because of illness, 10 years later John Thomas Clark settled in Hinckley and worked as a timber cruiser. He occupied many positions in the growing town, including mayor, justice of the peace, assessor, and game warden. In this last role, Clark obtained the first conviction for violation of game laws in Pine County. He was also a volunteer firefighter, but he was gone fishing on the fateful September day. Clark and a buddy had traveled to Lake Eleven, unknowingly placing themselves on the western edge of harm's way. Both men survived in the lake. The next day, they headed for home, stumbling onto a search party who announced that they were looking for J.T. Clark and an associate. "Well, you found him!" responded Clark. Only then did they hear that their hometown was destroyed. Later, at age 46, Clark wed for the first time, to 22-year-old fire survivor Lydia Tew (see page 32). (Courtesy of Doreen Axell.)

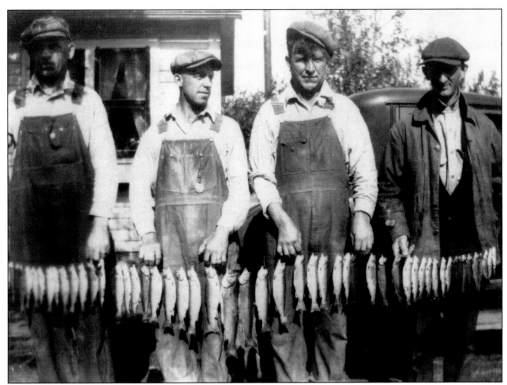

This smiling lineup includes, from left to right, Frank Lynch, Pete Williams, William Stanchfield, and Jim Glasier. Stanchfield was nicknamed "Bolivar" for his ability in hitting the "ball over" the fence. As the fire began consuming Hinckley, he warned his brothers to head for the gravel pit. Racing home, his neighbor's Newfoundland dog would not let him pass, thus saving his life by forcing him to run to the Grindstone River. He was the second husband of Lydia Tew Clark (see page 32). (Courtesy of Robert Peterson.)

George Turgeon was a depot agent and volunteer for the Hinckley Fire Department. After unsuccessfully battling the encroaching flames, he took refuge in the gravel pit. Mr. Wingren's cow was saved also, in what was usually used as her watering hole. After the danger had passed, Turgeon held the bovine while Rev. Mrs. Peter Knudson milked her. Using hollowed-out watermelon rinds, the sufferers drank water from the pit and milk from the cow. The Telesphore Turgeon family is pictured here. From left to right are (first row) Margaret and Eva (on grandfather's lap); (second row) Clare, Clara, and Telesphore; (third row) Rose, George, and Josephine. Their dog Prince was a victim of the fire.

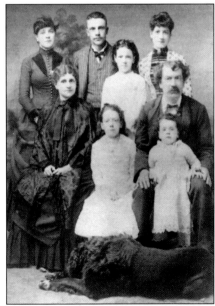

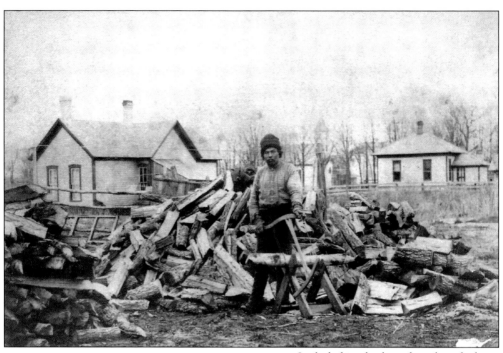

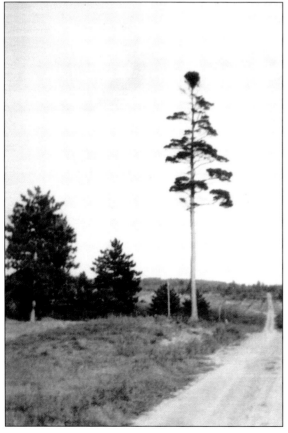

Included in the list of unidentified victims were folks just visiting or working in the area that fateful day. William Goodsell came from Wisconsin two months after the fire on a search to find his missing son. In a grave near Skunk Lake, he disinterred a charred body wearing a shirt fragment stamped with his son's laundry mark. Pictured here is horse trader Joe Harrison, who went missing after the fire.

Standing strong against the flames and gale-force winds of the fire was this single surviving white pine tree. It remained a landmark on the old government road east of Hinckley for many years. It eventually succumbed to age and the elements, but travelers will always remark upon a route named Lone Pine Road.

Dutch immigrants Joseph and Patronella Williams had settled in Hinckley. On that terrible day, as Joseph Williams was deciding whether his family should flee for their lives, Patronella was soaking the family savings in water and stuffing it in her purse. After escaping on the Eastern Minnesota train, she heated up a flatiron, removed the still-damp money from her purse, and pressed it flat and dry. (Courtesy of Robert Peterson.)

Annie Hawley Scott and daughter Margie survived the flames, along with husband and father, Walter, by fleeing on the Eastern Minnesota train. He was the manager of the Brennan Lumber Company general store in Hinckley. After the fire, the family relocated to Sandstone and opened their own mercantile. (Courtesy of Annie Marczak.)

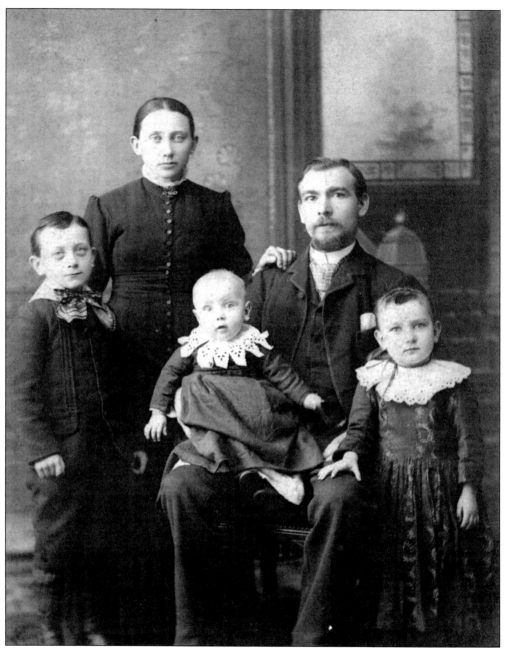

Ten-year-old Oscar Risberg became separated from his family at the Eastern Minnesota depot and was literally thrown by the seat of his pants into a crowded boxcar. Upon arriving at Duluth, he was lodged with other young boys on a boat in the harbor. After three days, he was brought to a large room at the Bethel Hotel filled wall to wall with mattresses. His mother spied him from across the room and came bounding over everything to wrap him in a tearful hug. His siblings were there also, but his father was never found. This photograph shows a grown-up Oscar with his wife, Hannah, and children (from left to right) Oscar Jr., John, and Jennie. (Courtesy of the Risberg family.)

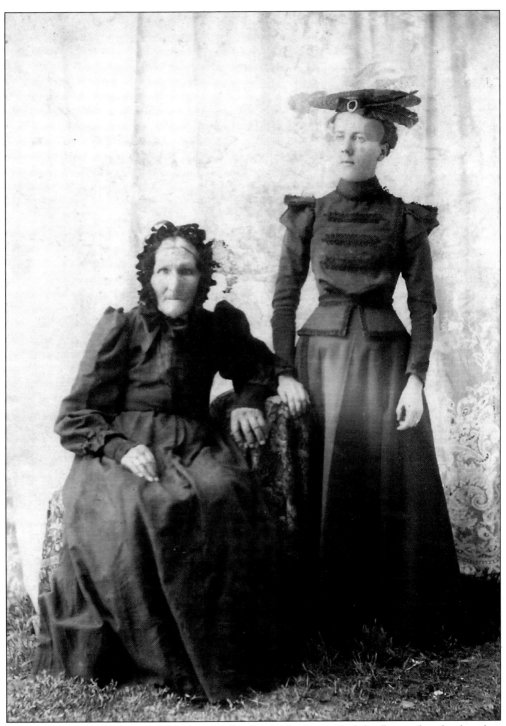

Mary McNeal and her adopted daughter Mollie Cooley both survived the flames that day, but they had different experiences. Cooley ran north of Hinckley along the railroad tracks and boarded the train that drove in reverse for six miles to Skunk Lake. The 80-year-old McNeal was saved by wading in the Grindstone River.

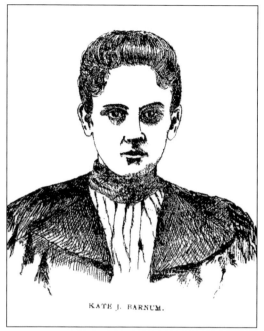

KATE J. BARNUM.

September 1 was supposed to be an exciting day for 13-year-old Kate Barnum of Pine City, Minnesota (left). Her parents had given her permission to travel alone on the train to Hinckley and spend the day shopping for new school clothes. As the weather became increasingly ominous, townspeople began racing around in terror. Waiting for her train that did not arrive, she began to feel alone and abandoned. Kate insisted to Good Samaritans that she could only ride the southbound train, but Methodist minister Rev. Shannon finally convinced her to join him on the Duluth-bound train. As word reached Pine City about the raging forest fire, her father, Dr. E.E. Barnum (below), began setting up temporary emergency hospital facilities. Then, the doctor and his son Eugene traveled north by railroad handcar to assist possible victims, unaware if his daughter was dead or alive.

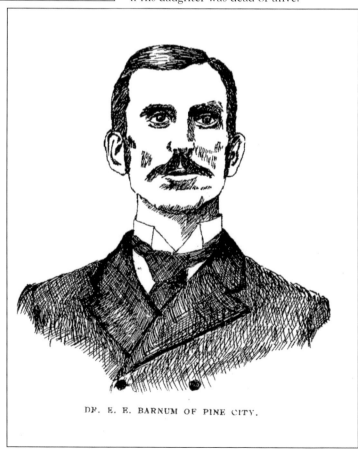

DR. E. E. BARNUM OF PINE CITY.

Four
SEARCH AND RESCUE

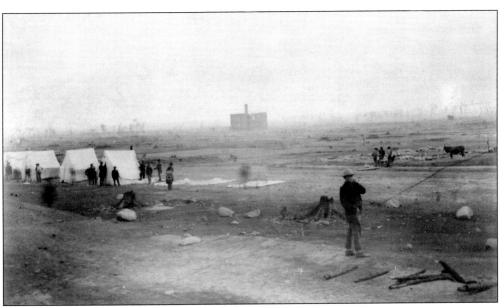

This view indicates how the town of Hinckley was completely wiped out. At left, rescue workers erect tents for shelter. In the distance at center stands the remaining hulk of the new schoolhouse. On the right in the distance stands an outhouse that was untouched by the fire. When Dr. E.L. Stephan returned to Hinckley the next day, he heard a sorrowful howling from the outhouse, opened the door, and discovered a horribly burned but alive kitten.

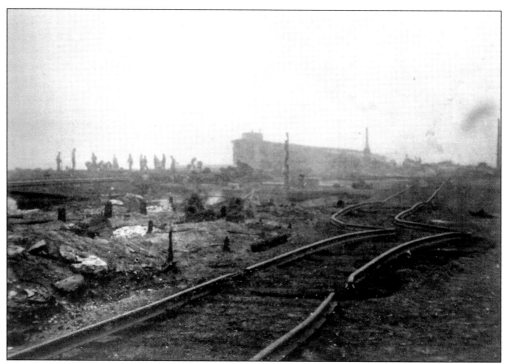

This is where the St. Paul and Duluth Railroad depot in Hinckley stood on the morning of September 1, 1894. By late afternoon, the building had been completely incinerated, leaving behind a twisted trail of track, warped from the intense temperatures.

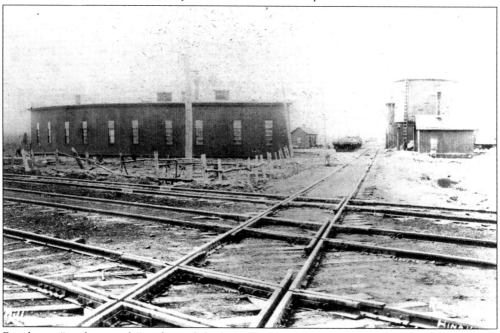

Besides an "outdoor castle" and a tool shed, the Eastern Minnesota roundhouse and water tank were the only two structures in Hinckley left standing. Once the flames had passed, many survivors took shelter in the roundhouse until help arrived.

Early in the rebuilding efforts, a few wooden structures were hastily erected, including a shed where the Fire Relief Commission conducted its business. Many survivors that decided to stay and rebuild resided in tents until their new homes were completed.

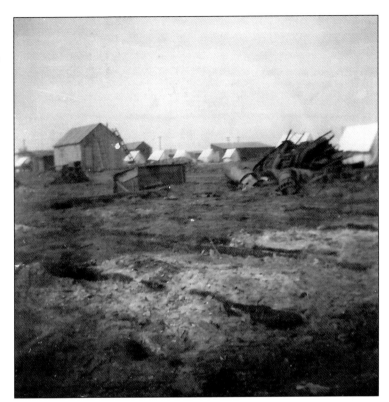

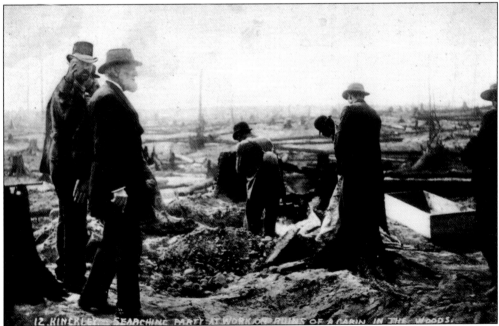

The gruesome task of finding, identifying, and burying the bodies began immediately. The hot weather persisted, making the job even more miserable. After the first few days of recovery efforts, decomposition of the victims had progressed to the point that they were buried where they were found.

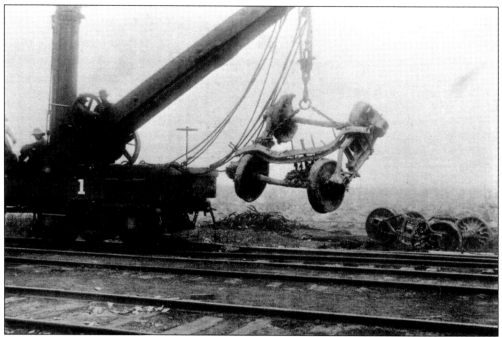
Cranes were brought in to clear the tracks of the remnants of cars marooned on the rails. Just 48 hours after the red demon had wreaked havoc on local transportation, passenger and freight service was restored between St. Paul/Minneapolis and Duluth/Superior.

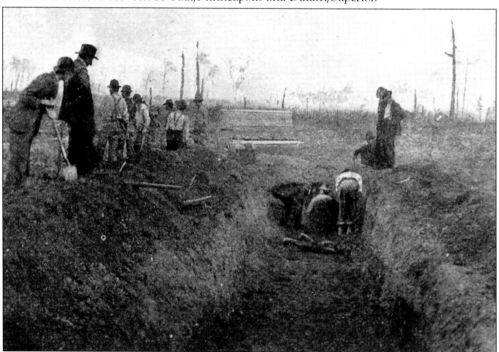
Desperate family members searched amid the four burial trenches where unidentified victims had been taken. Their hopes of finding a distinguishing mark or object to bring closure to their nightmare were usually dashed.

The poignant penciled notation on the reverse of this photograph states, "All my possessions the day after the Hinckley Fire—Alex Weser." Weser immigrated to America from Germany in 1881, locating near Hinckley in April 1894. He farmed with his father and brother Richard on the 160-acre homestead on the western edge of Pine County. These settlers had backfired around their property in an attempt to save themselves and their possessions from the threat of fire that droughty summer. Weser's wife had fortuitously traveled south to St. Paul on the day of the great conflagration. Alex Weser chose to rebuild his homestead and lived in the area the rest of his life. In 1899, he generously donated land for the establishment of School District 38.

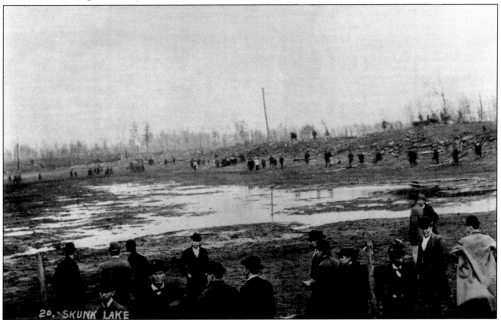

In the light of day, it was hard to understand how more than 250 refugees survived the holocaust in this miserable swampy lowland known as Skunk Lake. Here, its shores are lined with curious sightseers after the fire.

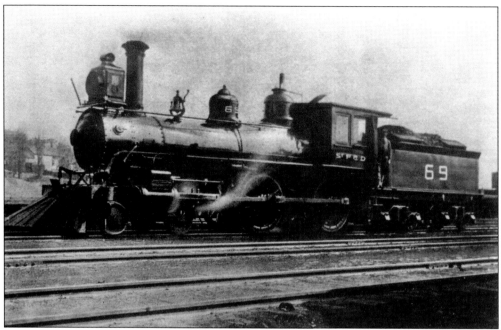

Engineer James Root drove his engine No. 69 and seven cars filled with refugees and freight in reverse for six miles before reaching Skunk Lake. After arriving, he insisted that his fireman, John McGowan, unhook the engine from the burning coal car immediately behind it, ultimately saving it from severe damage. After the fire, No. 69 was repaired and put back into service.

This train crew includes African American porter John Blair (second from right). On Root's reverse run from Hinckley to Skunk Lake, Blair performed his usual duties with remarkable calmness, reassuring the terrified passengers, distributing wet towels, and using the onboard fire extinguisher to douse their flaming clothing. Blair was one of the last men off the train after it reached Skunk Lake.

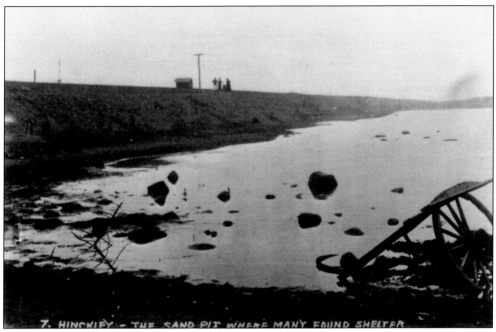

Before the fire, Hinckley townspeople would have considered this location an unlikely haven in any kind of emergency. The village eyesore was generally ignored except when it was time to water the cattle and horses. However, of the 100 plus people who sought shelter in its three-foot-deep water, everyone was saved from the flames except for one man who reportedly was knocked down by a cow and drowned.

George Nevers was a cook for one of the Brennan Lumber camps and had a restaurant in Hinckley before the fire. After escaping with his family on the Eastern Minnesota train, Nevers returned and was in charge of the eating house for the Fire Relief Commission.

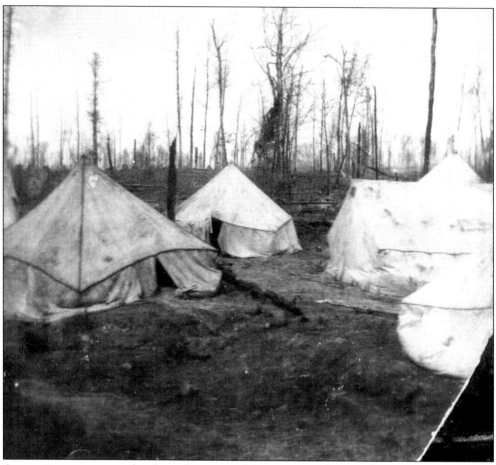
A tent city grew among the charred remains of the once-great forest. The residents of Hinckley called these canvas shelters home until new houses could be constructed.

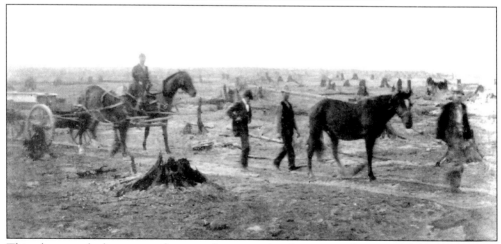
This photograph shows one of many solemn parades that escorted victims of the fire to their final resting place. Neighboring towns sent horses and wagons for hearses, along with lumber for coffins.

Dr. D.W. Cowan came to Hinckley in 1891 and became the town's first doctor. He was also Pine County coroner and was responsible for all official information regarding the victims of the Great Hinckley Fire.

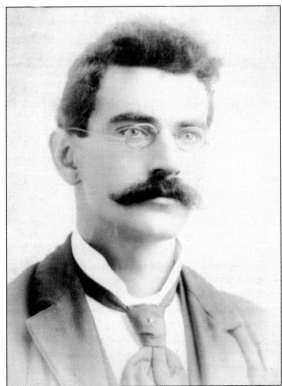

Dr. Ernest L. Stephan graduated from the University of Minnesota Medical School and, in 1893, joined Dr. Cowan in his medical practice in Hinckley. Stephan estimated that he carried about 20 children on board the Eastern Minnesota train before boarding a car to save his own life. He returned to Hinckley the very next day to aid the fire survivors. Stephan spent his entire career in Hinckley, delivering almost 5,000 babies.

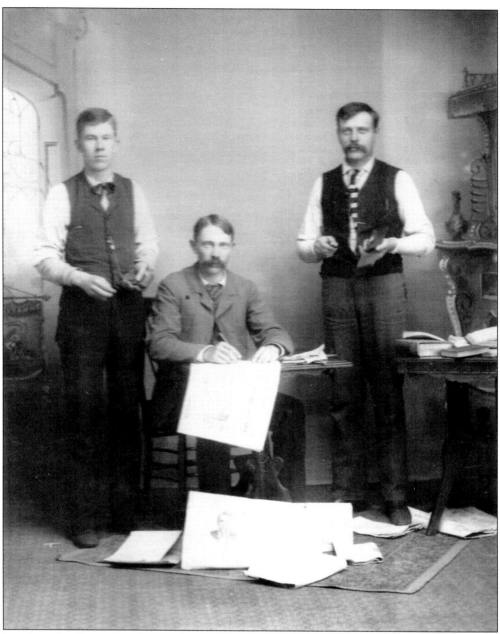

Just days after September 1, a trainload of newspaper editors traveled through the burnt district, heading to a convention in New York. John P. Mattson, editor of the Warren, Minnesota, *Sheaf*, described the scene to his readers as a "suburb of Hades." Residents in his hometown responded to his appeal to aid in the relief effort. The sum of $478.10 was raised from the sale of a boxcar load of local wheat. Years later, Mattson's grandson E. Neil Mattson represented the Minnesota Historical Society and was a speaker at the 75th-anniversary fire memorial ceremony. This 1892 photograph identifies Ole Forde (left), Mattson (center), and Victor Peterson. Note Knute Nelson's photograph on the *Sheaf*. Nelson was the first Scandinavian-born American to be elected to the US Senate. (Courtesy of the Mattson family.)

Five

RISING FROM THE ASHES

Margaret McNeal (left) had resided in Hinckley since 1878, which established her as one of the early pioneers. She survived the catastrophe along with her daughter Mary (right) by making it to the nearby Grindstone River. The Fire Relief Commission approved the larger-sized, No. 2 relief house for her family of three. Along with the other basic items distributed to all survivors, they were issued three washtubs ($1.50), one wringer ($3), and a washboard, plus $5 in cash to purchase soap and bluing for their laundry business. McNeal lived for 11 more years, dying from "old age" on a date estimated to be just shy of her 100th birthday.

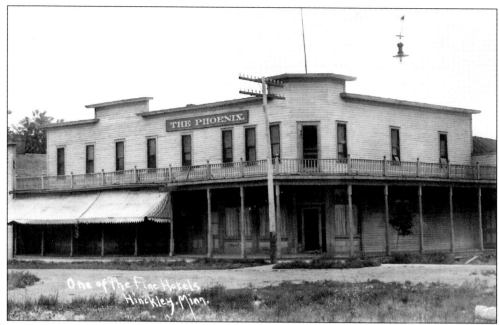

Just months after flames leveled the town of Hinckley, fire survivor B.C. Bartlett built this hotel and named it after himself. In 1903, B.J. Rolle purchased the inn and decided to rename the business. He distributed printed cards among traveling salesmen and offered a prize for the best suggestion. The winning entry, "Phoenix," refers to a bird in Egyptian mythology that was consumed by fire and later rose, renewed, from its ashes.

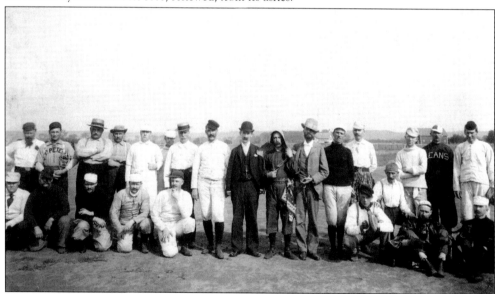

A charity baseball game was held in St. Peter, Minnesota, with all contributions donated to the fire victims in Pine County. The "Fats" competed against the "Leans," raising $261.60 for the cause. The rules of the game were fast and loose, as evidenced by the hooded man in the center carrying a revolver; possibly he was the umpire? The gentleman standing on the far right is future three-term Minnesota governor John A. Johnson. He was the state's first governor to be born in Minnesota following statehood. (Courtesy of Nicollet County Historical Society.)

Seba DeBoer is pictured in front of a No. 1 relief house. The Fire Relief Commission awarded funds and building supplies for a simple 16-foot-by-24-foot frame house to small families and couples who desired to remain in the area. Bachelors did not qualify for a house unless they had owned a dwelling before the fire. The house could not be built on mortgaged land. Upon completion, it was furnished with basic furniture, utensils, linens, and tools. The survivors were also given a three-month supply of food and feed for the family horse or cow. Even with adequate shelter, the long winter was a trial for the pioneers who resettled the area. The commission's final report declared that 2,636 people had been given aid and 215 new houses were built in the burned-over area.

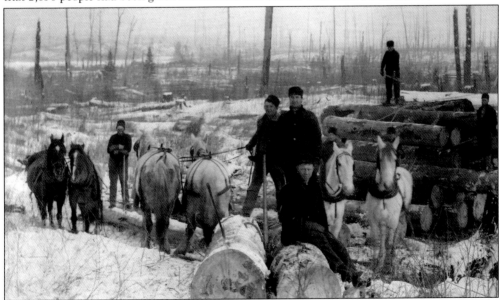

The Great Hinckley Fire spelled the end of commercial logging in most of the area. Some entrepreneurs, seeing value in the blackened stumpage, worked at salvage logging. (Courtesy of Ed Ness.)

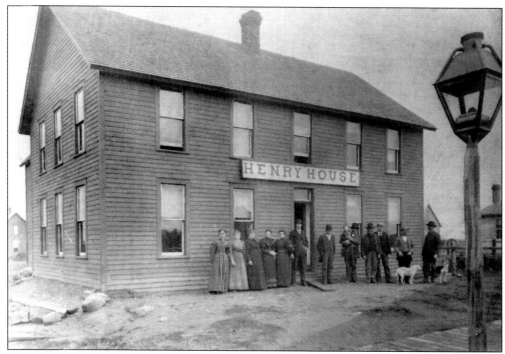

Nelson Henry and his wife owned the Henry House in Hinckley before and after the fire. The couple saved themselves in the gravel pit, but they lost their treasured team of horses in the disaster. After the fire, they set up their boardinghouse in a tent until a new structure was built. Local logging firms presented Nelson Henry with a fine set of horses to replace the team that had perished. Note the hand-hewn light post in the foreground.

All fire survivors were required to complete a registration form that gave the Fire Relief Committee basic information to assess the needs of each victim. Form No. 482, shown here, was filled out by Emma Hammond, who ran a "sporting house" just east of Hinckley. Hammond was horribly burned and transferred to Minneapolis for treatment. This committee allotted a dollar a day to the hospital for her care.

Gustav Peterson, pastor of the First Lutheran Church in Hinckley, was not in town on the day of the fire. He returned to a pile of ashes where his church once stood and a congregation that had lost eight members. The resilient parishioners rallied and celebrated Christmas 1894 in a new house of worship. Incredibly, just 20 months later, a cyclone destroyed this church, and the membership was faced with another rebuilding project.

Brick and stone were used to construct this traditional hearth oven. The slow and steady heat released by the wood-fired process produced wonderfully baked breads. This bakery employed Joe Armsburger Jr., son of fire survivor Jane Tew Armsburger.

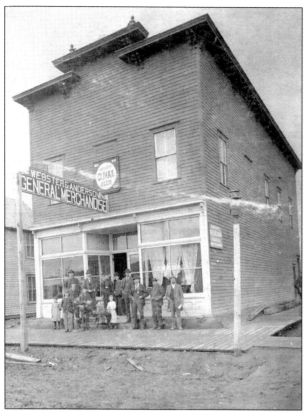

In 1896, fire survivors Lee Webster and J.K. "Big John" Anderson became partners in a general mercantile. The progressive merchants installed a streetlight on their corner, which was actually a kerosene lamp that required daily refueling. The man standing to the immediate left of the door is Webster, and Anderson is standing to the right of the door. Note the town marshal standing next to Anderson.

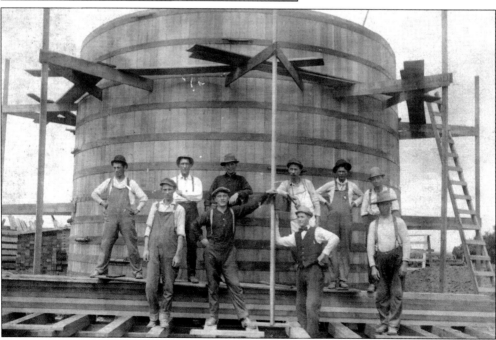

This crew pauses while rebuilding the water tank for the St. Paul and Duluth Railroad. It later became known as the Northern Pacific Railroad. (Courtesy of Robert Peterson.)

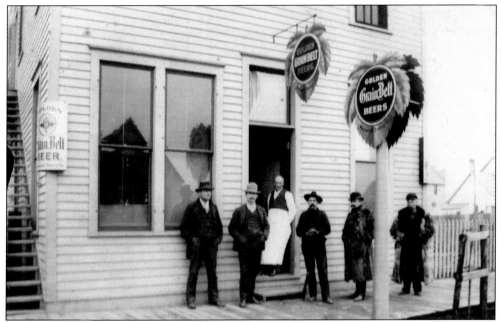

Saloon keeper John T. Craig was chief of the 19-man Hinckley Volunteer Fire Department in 1894. The fire alarm sounded between 1:00 p.m. and 2:00 p.m. on September 1. The crew fired up the steam for their new Minnesota-manufactured Waterous fire engine and battled the strengthening blaze for the next two hours. When the water hose between the engine and the brass nozzle burned through, Craig deemed the situation hopeless and ordered the volunteers to go save their families. The identified persons shown here are Craig (second from left) and E.B. Jennings (fourth from left).

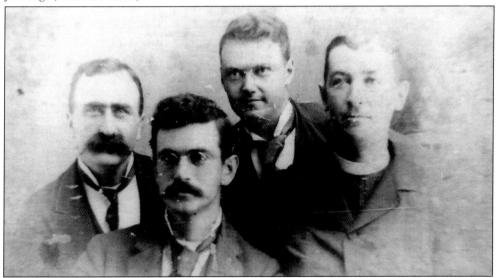

These four heroes of the Great Hinckley Fire are, from left to right, Dr. D.W. Cowan, Dr. E.L. Stephan, editor of the *Hinckley Enterprise* Angus Hay, and Catholic priest Fr. E.J. Lawler. After saving himself in the gravel pit, Hay travelled by handcar and train to reach Pine City and confirm the news of Hinckley's annihilation. After losing everything but his subscription book and some files, his newspaper was back in print four months later.

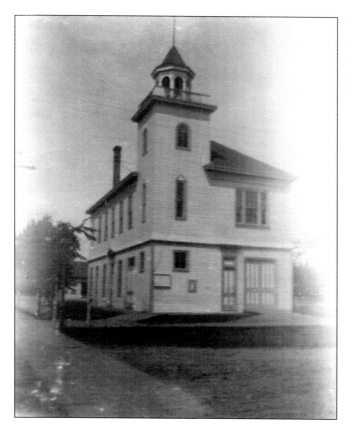

The City of Hinckley rebuilt its town hall on the footprint of the original building. It was dedicated on May 1, 1895.

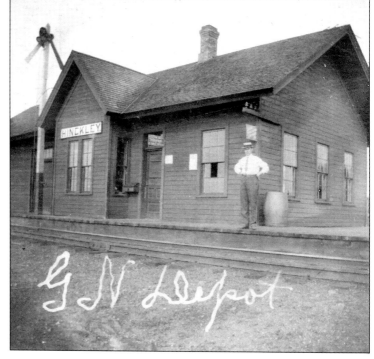

The Eastern Minnesota railway was a division of the Great Northern commandeered by Minnesota business magnate James J. Hill. The Great Northern's Hinckley depot is shown here in a post-fire photograph.

Dora (second from left) and Elizabeth Williams (far right), along with six family members, made their getaway aboard the Eastern Minnesota train. Upon reaching Duluth, their parents realized that five-year-old Elizabeth had become separated from them. Her father searched the schools and churches for several days before she was located at the armory. The entire family survived, including a cow that was found in Pine City, 13 miles south of Hinckley. (Courtesy of Robert Peterson.)

Fire survivors Otto Hulke and Frank Mortenson gambled on the rebuilt economy of Hinckley. In 1900, the partners opened the Hinckley Cash Store, located on the corner of today's Highway 61 and First Street NE. The establishment's inventory included flour that was locally milled in Pine City and patented under the names "Buttercup" and "Golden Key."

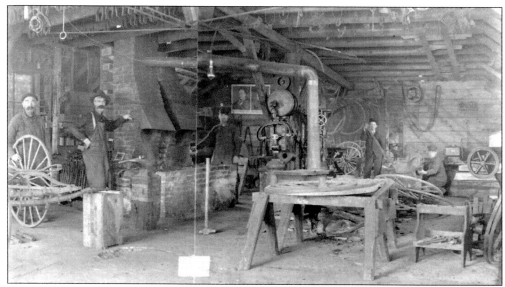

Every booming town needs at least one blacksmith shop. Considering all the equipment, including the double-sized forge, this growing concern looks ready to handle all the needs of a village that has been "reborn from the ashes." In the center of the photograph is a steam or gas hammer, an early laborsaving device. The political poster of Taft and Sherman on the back wall dates the photograph to around 1909. The clear glass lightbulb indicates that the town already has an electrical plant. Shown standing here are, from left to right, fire survivor John Roscoe Stanchfield; the owner, Bill Leonard; and another fire survivor, Dan McLaren. The two young men on the right are taking an interest in the trade.

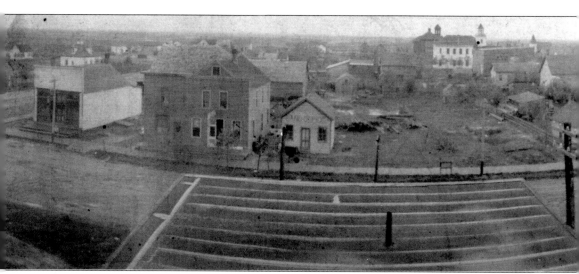

This panoramic photograph of Hinckley was taken in 1903, just nine years after the town was leveled. The Minnesota Mutual Telephone Company had just established telephone service, and many businesses eagerly signed up for this modern convenience. Note the telephone pole in the

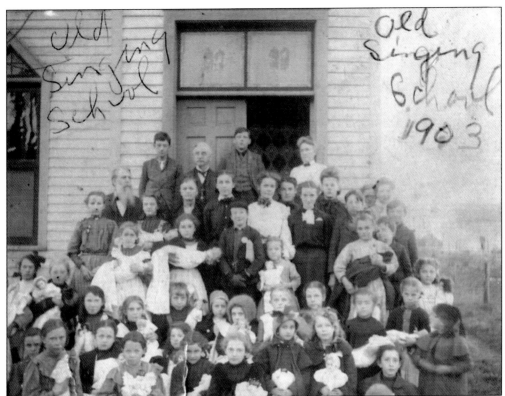

After losing its building in the great fire, the Presbyterian congregation in Hinckley erected a new house of worship by November 1895. In 1903, the members hosted a singing school. Classes were often taught by traveling singing masters. The school's goal was to teach youngsters how to sight-read music, which encouraged them to sing along at services. This photograph was taken at the end of the session. These schoolgirls were allowed to bring their favorite dolls on the last day.

middle foreground. Visible in the background are the bell towers of the town hall and the school. (Courtesy of the Pine County Historical Society.)

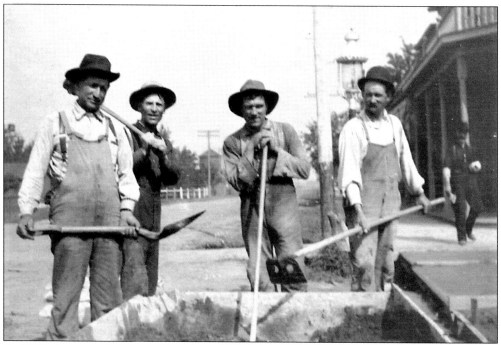

By 1905, the town fathers in Hinckley were modernizing their village streets by constructing cement sidewalks. Note the decorative streetlamp on the right side of the photograph. The second man from the left is fire survivor William "Skinner" Parsons.

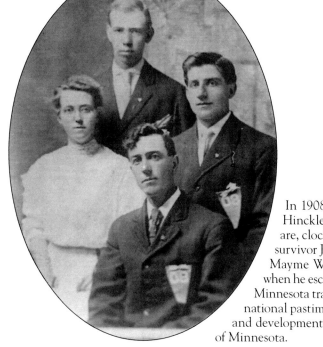

In 1908, the second class graduated from Hinckley High School. The four members are, clockwise from top, Art Anderson, fire survivor James Brennan, James Mullins, and Mayme Wallick. Brennan was six years old when he escaped to Duluth onboard the Eastern Minnesota train. As he grew up, he embraced the national pastime of baseball, promoting its growth and development on the amateur level in the state of Minnesota.

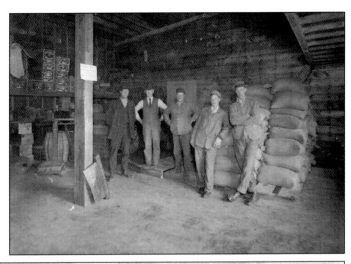

After the fire, farmers discovered that potatoes grew well in the burned-over soil. At one time, Hinckley was home to four potato warehouses. Shown here is the interior of fire survivor John Patrick's storage facility in 1909. Posing are, from left to right, Harvey Reid, Charles O'Malley, Roy and Frank Patrick (John's sons, both fire survivors), and Arvid Anderson.

All Hinckley Town Council members survived the catastrophe, including Mayor Lee Webster. He had settled in the town in 1877, finding work in the lumber trade as a teamster and a saw-setter in the mills. In 1890, he opened the first furniture store in town. The newspaper editor commented that his motto should be "Birth, Marriage, and Death" because his inventory included baby carriages, home furnishings for newlyweds, and coffins. During the fire, Webster saved himself in the shallow water of the gravel pit, but he lost his wife, Belle, and his parents in the disaster. He called the first meeting of the Hinckley Building Association on September 10, just nine days after the town completely burned down. He reestablished his business three months later, and in 1896 he married another fire survivor, Nellie Brennan. This 1910 photograph shows Webster standing in the doorway and Nellie demonstrating a modern-looking lawn chair. The poster in the store window advertises an exhibition baseball game.

Before September 1, 1894, John Currie owned and operated the local drugstore in Hinckley. After the fire destroyed his business, Currie became a land agent. Here, he displays local crops in the shop windows to attract potential buyers.

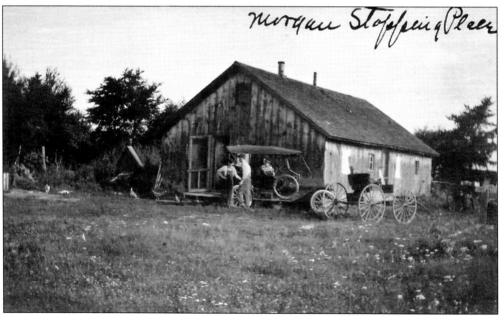

Mr. Morgan established an oasis for the early traveler on Little Sand Creek, 13 miles east of Hinckley on Dewey Avenue (present-day State Highway 48). Available accommodations included feed for horses and humans and lodging for the night. In a pioneer version of a tourist attraction, gypsies camped nearby to hawk their trinkets and tell fortunes to the newly arriving homesteaders.

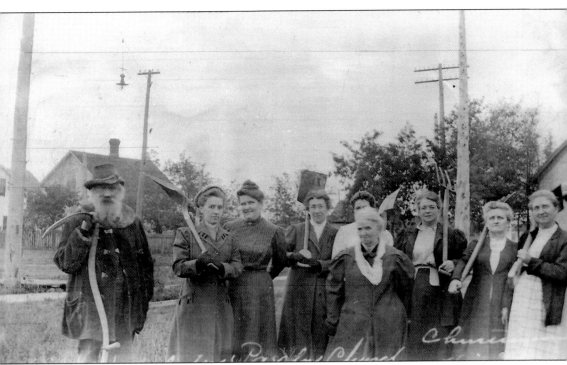

Throwing shovels of dirt at the ground breaking for their new structure in 1911 are Presbyterian Ladies' Aid members, including (in no particular order) Mrs. Jackson, Christianson, Noble, Holbert, Swain, Campbell, and Randall. The gentleman on the left appears ready to reap their efforts.

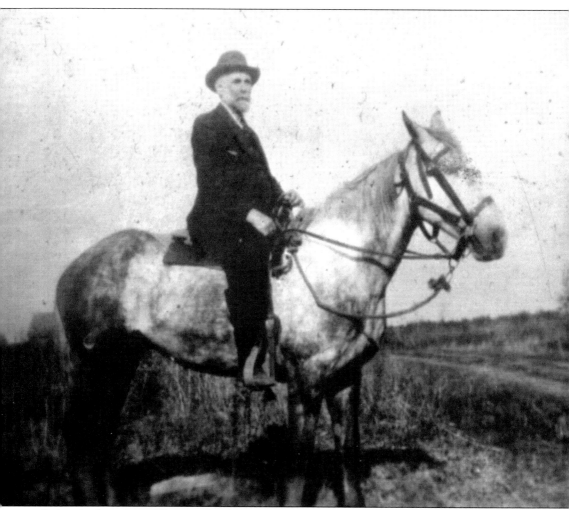

Riding high in the saddle is Frederick Victor Goff, who moved to Hinckley in 1903 at the age of 59. In his earlier years, he served in the Civil War as a musician and was involved at the Battle of Gettysburg. In 1879, he served the State of Minnesota for two years as a representative in the legislature. His teaching career spanned 52 years and included terms in 10 Pine County school districts. His salary ranged from $30 to $45 per month.

Six

NEW KIDS ON THE BLOCK

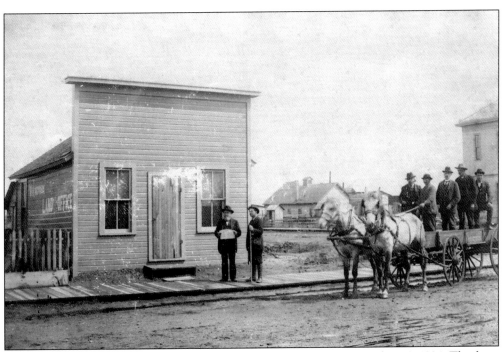

The first post-fire issue of the *Hinckley Enterprise* was printed on December 19, 1894. The front page proclaimed the positive aspect of the damage by announcing to readers, "The fire had accomplished in 15 minutes what it would take a husbandman 15 years to do." Because the land was effectively cleared for farming, the area became attractive to droves of men looking for cheap acreage. However, settlers in the burned-over district still had to deal with the problem of clearing out the stumps left behind; thus, homesteaders were often referred to as "stump farmers." Fire survivor W.H. Nowark was a land agent in Hinckley before and after September 1, 1894. This group of land-seekers appears ready for an excursion in the countryside. The McLaren blacksmith shop appears in the center background.

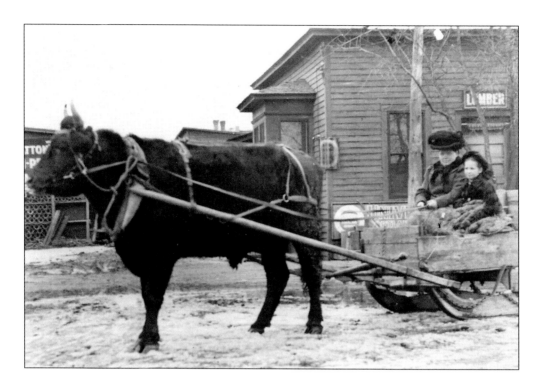

Pioneer women were fearless and self-reliant; it would take a real calamity to keep them from their once-a-month trip to town. It did not matter to Mrs. Profitt if it was winter or summer. She hitched up her ox, put on her best hat, and headed north to Hinckley. The lumberyard was a frequent stop for any homesteader because both of these photographs were taken in front of the Christianson-Innes Lumber Company. Below, her sun umbrella is printed with advertising promoting sales of Patton's sun-proof paints.

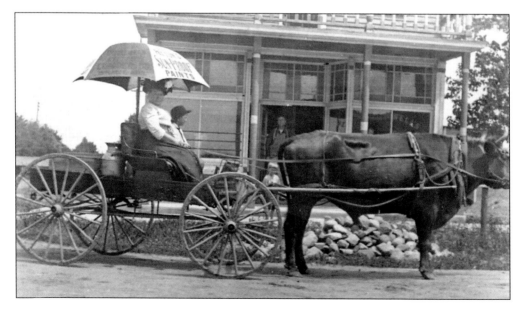

After being disabled in a runaway accident of a logging team, Ed Masterman (above left), and wife Cora (above right), moved to Hinckley, where he partnered with Sam Sutliff in 1904 as proprietors of the Home Plate Bar (below). Its advertising proclaimed, "A little whiskey now and then, is relished by the best of men; it smoothes the wrinkles out of care, and makes ace high look like two pair."

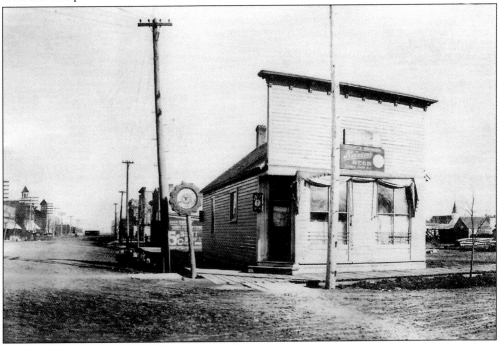

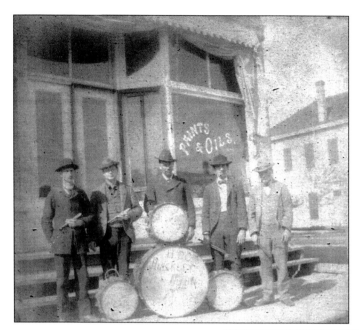

Homegrown entertainment could really "fill the bill" in the early days. The Hinckley Drum Corps included, from left to right, fire survivor Lee Webster, Joe Gimpl Sr., Lon Terwilliger, Maurice Brennan, and ? Shay.

John Von Rueden arrived in Hinckley in 1898 and settled on property two miles southeast of the rebuilt town. Here, he displays samples of mammoth red clover, which grew luxuriantly in the nutrient-enriched, post-fire soil. The plant produced a bountiful hay crop for northern Pine County farmers. It was also planted for erosion control on newly constructed railroad embankments.

A year after the disaster, a reporter from the *St. Paul Daily Globe* returned to Hinckley to follow up on the story. Included in his article was a sketch of the only house near Hinckley that had not been consumed by the inferno. The M.C. Dean residence, shown above, was later bought by Pine County for use as a poor farm. A poor farm was an early form of public assistance; elderly, disabled, or mentally ill inmates assisted with daily chores in return for food and shelter.

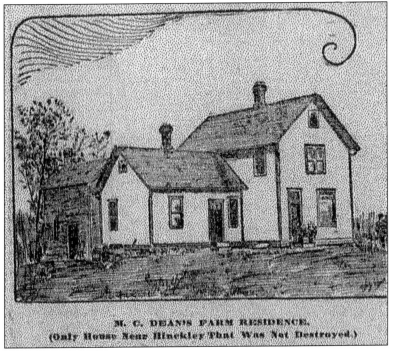

M. C. DEAN'S FARM RESIDENCE.
(Only House Near Hinckley That Was Not Destroyed.)

"Cap" Holbert was a businessman who settled in Hinckley for a few years after the fire. He and partner P.A. Christianson published a pamphlet called "Land of the Big Red Clover," which promoted the burned-over land to prospective buyers.

John Harth was a harness maker who had his shop in Hinckley after the fire. In the background is Mr. Bassett.

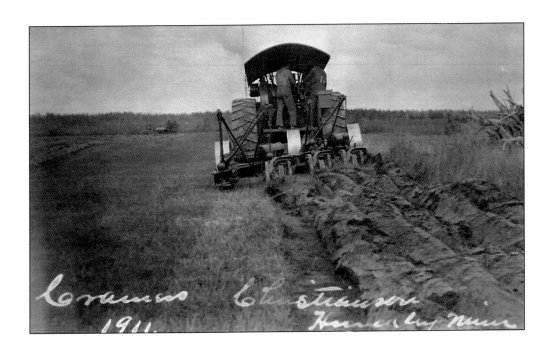

A steam-powered tractor made the job of plowing much easier for the new homesteaders. Neighbors often shared the use of equipment, allowing everyone to get their work done faster. These photographs were taken by realtor P.A. Christianson in 1911 for use in promoting his land sales in the Hinckley area.

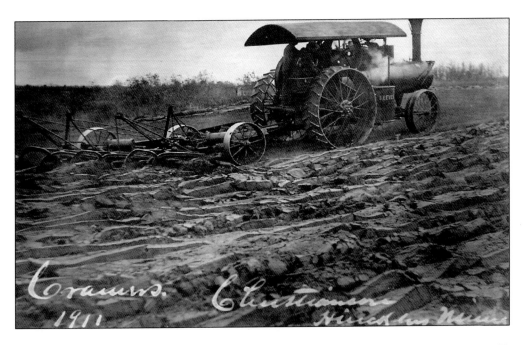

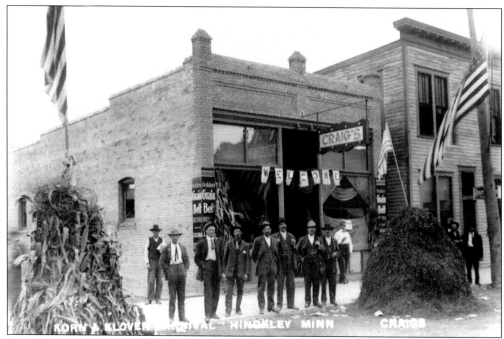

Proud Hinckley residents promoted their town by holding an annual festival. The large shock of corn on the left and the red clover haystack on the right displayed the quality of local crops that led to the nickname "Korn and Klover Karnival." While making allowances for the changing times, this tradition continues today. Saloon owner and fire survivor John T. Craig, wearing a white shirt, stands in the background in front of the storefront.

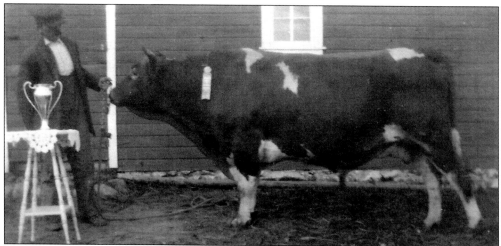

Homesteader Pete Nyberg lived in a small cabin east of Mission Creek and south of Hinckley. As the smoke thickened on September 1, he and his 16-year-old hired hand headed for the nearby creek. They wrapped themselves in water-soaked blankets and waited for the conflagration to pass. When Nyberg returned to the smoldering remains of his home, he realized that no one would give him 5¢ for what he owned, including the clothes on his back. In a few months, the Fire Relief Commission built a No. 1 house for him, and he started over. After 20 years of hardship, perseverance, and optimism, Nyberg's purebred Guernsey was awarded a silver loving cup for the best dairy bull at the 1914 Hinckley Korn and Klover Karnival. (Courtesy of Jeff Moffatt.)

Carpenters were in great demand when settlers decided to stay and rebuild their homesteads. These fellows were even working after the first snowfall. But, everybody needs to take a break once in a while. Shown here are, from left to right, Harvey Reid, fire survivors John T. Craig, Ed Mitchell, Vern "Pegleg" Stanchfield, and Ed Henry (with doughnut). The young apprentices in the background are David Christianson (left) and his cousin Ted Waller.

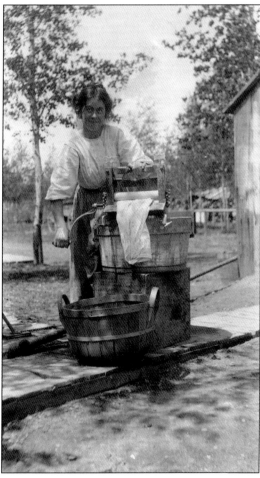

Men were not the only pioneers who worked long days. Here, Emma Sundean washes the weekly laundry.

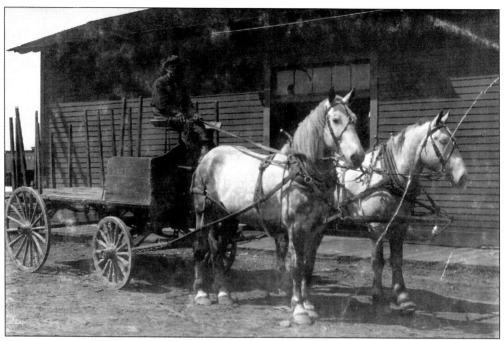
Fire survivor Carl Swanson was just four years old when he escaped the flames with his family on the Eastern Minnesota train to Duluth. The family returned to help rebuild Hinckley, where Swanson eventually started his dray business.

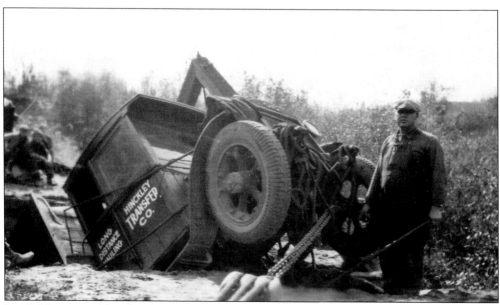
Joe Dehler opened his dray business in 1917. This photograph indicates that progress was not always easy.

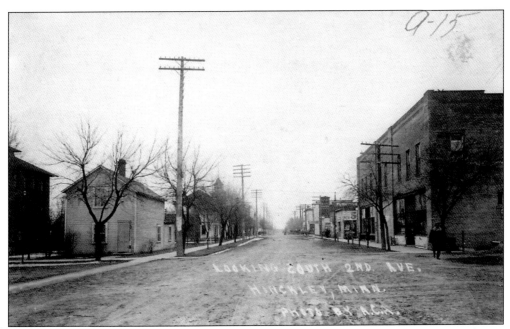

This rare view of Hinckley looks south on Second Avenue. It was renamed Lawler Avenue in honor of the town's heroic Catholic priest. The names of several other city streets were also changed to recognize fire heroes, including Barry, Blair, Dunn, Morris, Power, Root, and Sullivan.

Copper deposits were discovered in several Pine County locations. Investors began several mines along the Kettle River east of Hinckley, only to have them go bust in a few short years.

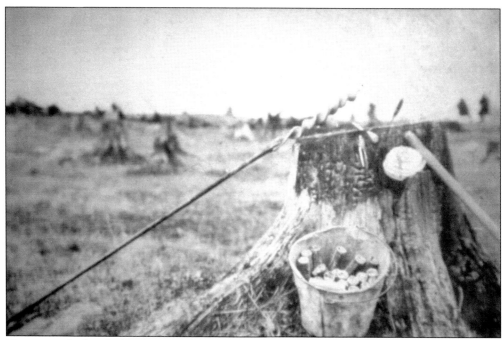
Newcomers had to deal with acres of stumps in order to farm their land. Shown here are the tools needed for blasting the stumps away: a hand auger and a bucket of dynamite sticks.

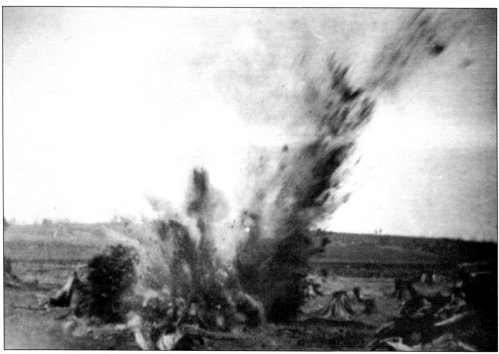
A dynamite blast rids the field of one stump and probably loosens several others. Note how many stumps remain to be removed.

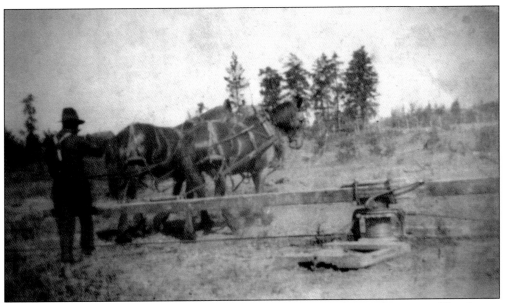

Some settlers chose to deal with the stump-clearing problem in a less explosive way. This farmer has his horses hitched to a rotating stump puller.

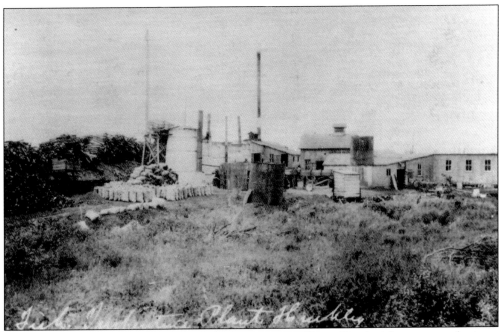

The stumps were a headache for farmers, but entrepreneur Henry Copilovich saw a great business opportunity. He recruited investors and built a plant for refining turpentine from the pine stumps left behind by logging and the fire.

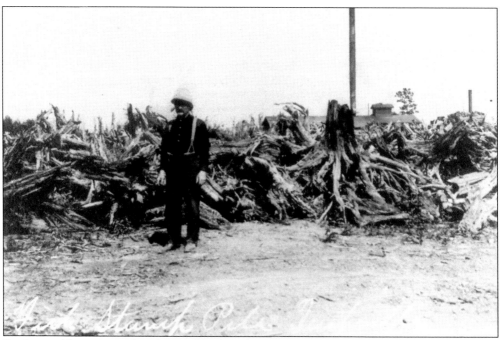

Settlers could earn as much as $3 a cord hauling their unwanted stumps to the Standard Turpentine Company refinery, located nine miles east of Hinckley.

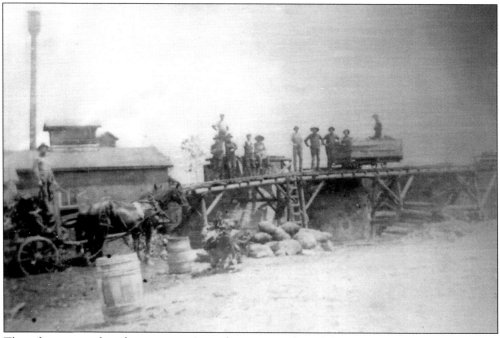

The refinery started production in 1903. Work crews complained about the bloodthirsty mosquitoes that thrived in the wilderness, claiming that one night they were awakened by a steam whistle, but it was only a giant mosquito amusing himself. A small settlement grew up around the industry and became known as Turpville. By 1908, the supply of stumps was depleted, and the refining equipment was auctioned off.

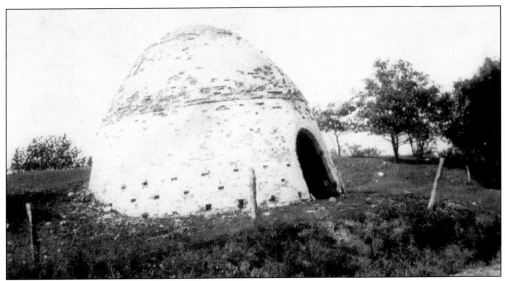

This is a leftover relic of the turpentine plant called a retort. The pine stumps were heated in this structure as a step of the distilling process.

By the 1930s, the Farmers and Merchants Bank was firmly established as the only bank in town. In August 1931, the building was entered by two masked gunmen who relieved the institution of $3,400. The crime was never solved, but those were the days of the Barker-Karpis gang in Minnesota. The nearby city of St. Paul was a safe haven for gangsters during the early Depression era.

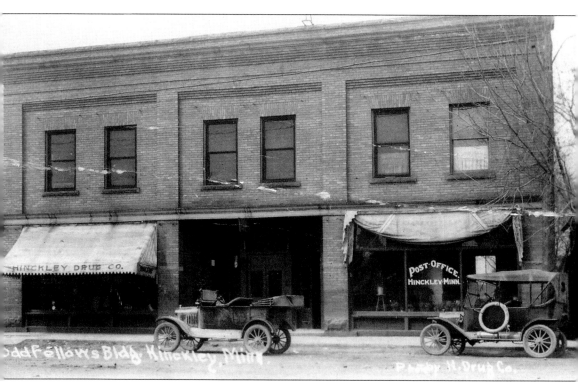

Hinckley's first postmaster was David E. Grant, who was appointed in 1870. The first known location of a post office was on the west side of town, across the St. Paul and Duluth railroad tracks. Its location moved frequently, mostly depending upon who was the currently appointed postmaster. It is pictured here on the north side of Main Street.

The faith of the Hinckley townspeople remained staunch, even after the holocaust stripped them of all their worldly possessions. The Lutheran, Presbyterian, and Catholic congregations all eventually rebuilt their houses of worship along present-day Lawler Avenue. Looking north, note the dirt streets and electric streetlights. Trees that had been planted along the sidewalks are beginning to mature.

After outliving two husbands and surviving the Great Hinckley Fire of 1894, Lydia Dethick passed away at the age of 89 in 1919. Too disabled to board the Duluth-bound train on September 1, Dethick's son-in-law Joe Tew transported her to the Grindstone River, where she sat on a small island. As the firestorm raged over them, Father Lawler wet his surplice and covered the old lady with it, saving her life. Pallbearers at her funeral included pioneers Mullins, Frye, Brennan, Gage, and Fleming. (Courtesy of Roberta Johnson.)

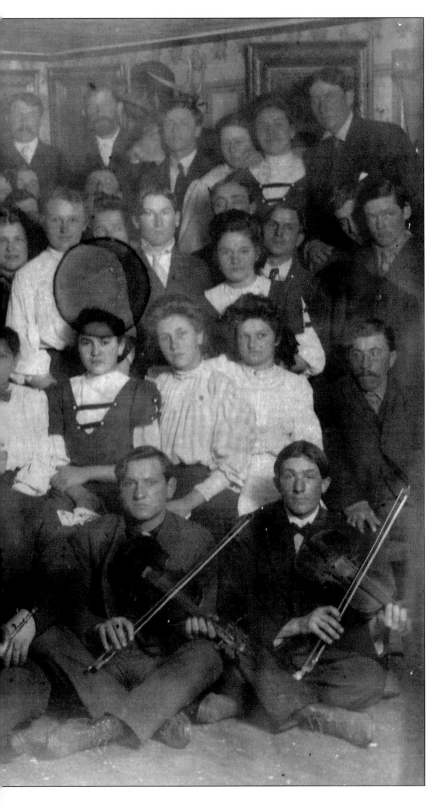

The Joseph Hakert family settled west of Hinckley in 1897. Here, neighbors and friends, including the Kroschels, Tews, Busses, Ubls, and Brennans, are gathered at their farm for a barn dance.

Hinckley has a great baseball history. Even before the fire, the town had a team named the Crescents. By 1895, a new lineup was organized called the Monarchs, whose players included fire survivors Dunn, Brennan, and Stanchfield. This group of little rascals hoping to make a future town team are, from left to right, (first row) Elmer Pappe, Bud Stanchfield, Red Stanchfield, Bob Stanchfield, and J.D. Brennan; (second row) Charles Von Rueden, Joe Fleming, unidentified, Pascal Clark, and unidentified. The current team, the Hinckley Knights, still compete in the Eastern Minny League, the oldest league established in the state—with a Brennan family member still involved in the organization. (Courtesy of Robert Peterson.)

Berry picking was a common pastime before and after 1894. Cranberries were plentiful in the swampy lowlands. After fire had swept through the cutover land, conditions were ripe for blueberries to thrive. The fruit, considered a cash crop, was shipped via rail on the "Blueberry Special" to metropolitan markets. Horatia Lyon (right) and a friend appear to have enjoyed their day on the family farm east of Hinckley.

Kate Egan was appointed the Hinckley postmaster in 1896 (the post office did not recognize postmistresses at the time). Her appointment in 1904 caused a political uproar in the small town when Republican congressman J. Adam Bede named Egan, a Democrat, to the position. She operated the fourth-class office in conjunction with her confectionery and gift shop.

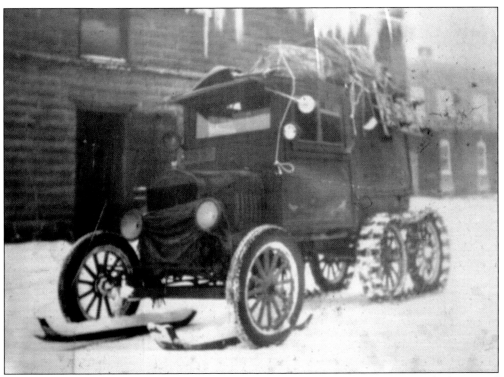
Early mail carriers were a dedicated lot. They worked in any kind of weather and had to travel on muddy and snow-filled roads.

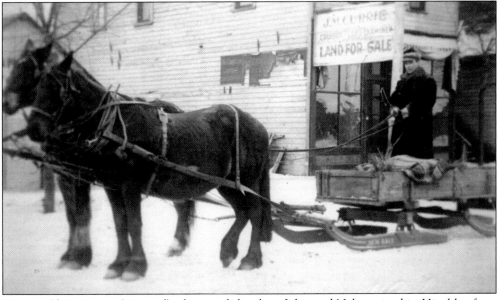
Magnus Christianson (pictured), along with brothers John and Nels, arrived in Hinckley from Iowa in 1904. They bought adjoining acreage near Turpville and started farming. After the refinery closed, the land was promoted more for its agricultural opportunities, and the community was renamed Cloverdale. By 1921, enough farmers had moved into the area to establish a cooperative creamery with Magnus serving as its first secretary.

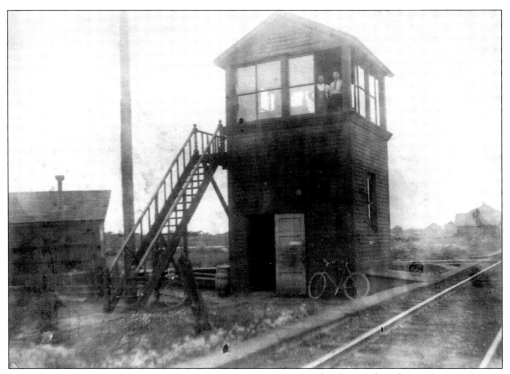

The first railroad signal tower in Hinckley was built in 1895. From here, two telegraph operators worked alternating 12-hour shifts. They also handled the levers for switching the tracks.

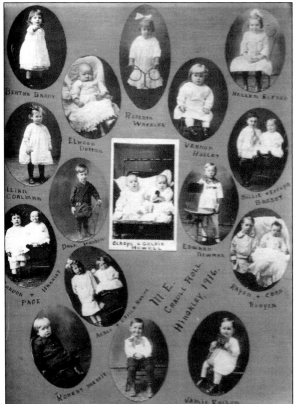

The Hinckley Methodist Episcopal Church sponsored this photo collage of youngsters in 1916. Commonly referred to as a cradle roll, children were enrolled by a house of worship at an early age to begin their religious education. It was a practice favored by many denominations and used as a link to keep families in their congregation.

Seven
NO ORDINARY FIRE

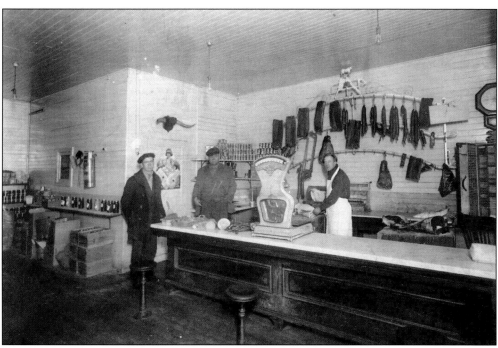

Charles J. Pearson immigrated to Sandstone, Minnesota, and worked as a stonecutter in the quarry in 1888. He fortuitously traveled to Sweden for a yearlong visit in 1894, thus being absent during the holocaust that descended upon his adopted hometown. When he returned, Pearson engaged in the mercantile business, was a road-building contractor, and became a director of the Sandstone State Bank. Along the way, he trained young Harry Hammarstedt in the art of meat cutting in his butcher shop. Hammarstedt was five years old when he and his family suffered through the hardships caused by the fire. Note the fire extinguisher hanging on the wall above the row of home-canned goods. Meat orders are being weighed on the Stimpson Computing Scale, and a variety of smoked bacon, sausages, and hams are displayed on a decorative wall rack. Charles Pearson (center) and Harry Hammarstedt (right) pose here with an unidentified man.

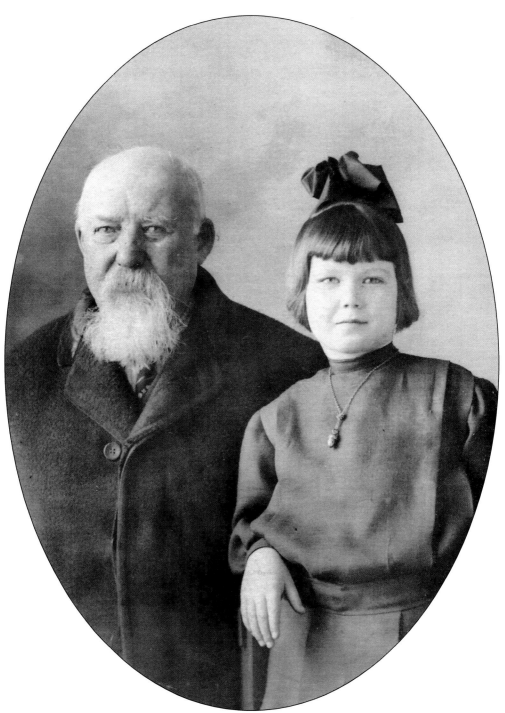

Widower Ed Linehan moved to Sandstone in 1889, the same year the town was incorporated. He earned his way up to a job as superintendent with the Ring and Tobin Company, which operated the quarry that gave the town its name. His family, including children Patrick, John, Catherine, Ellen, and Cornelius, were saved in the Kettle River. Linehan is pictured here with his granddaughter June Wade. (Courtesy of Linda Troolin.)

Erick Troolin (below, with wife Christina) was a master of many trades, including masonry. Using sandstone from the local quarry, he constructed an autographed archway to an underground storage room (at right). He also operated a sawmill in Sandstone for six years before the firestorm destroyed everything but his family, who were all saved wading in the Kettle River. The sturdy structure he had crafted nine years earlier provided protection for a wedding party that had gathered near Sandstone Junction. Before the ceremony commenced, members of the party noticed the threatening skies and dashed for the Troolins' root cellar. The refugees discovered cans of milk stored inside and splashed milk on the wooden door and on themselves. Following the fire, three days later, Minnie Samuelson donned a donated dress and exchanged vows with John DeRosier in Duluth, witnessed by a crowd of refugees and the family dog. (At right, courtesy of Al Wolter; below, Linda Troolin.)

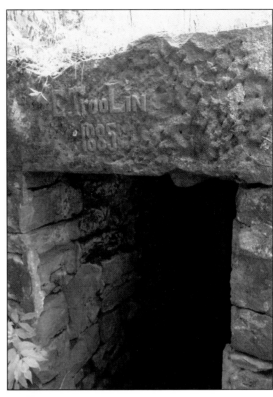

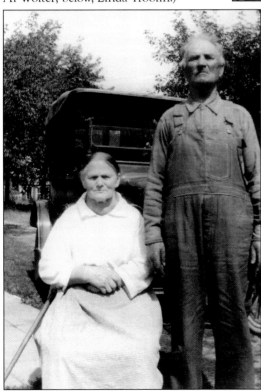

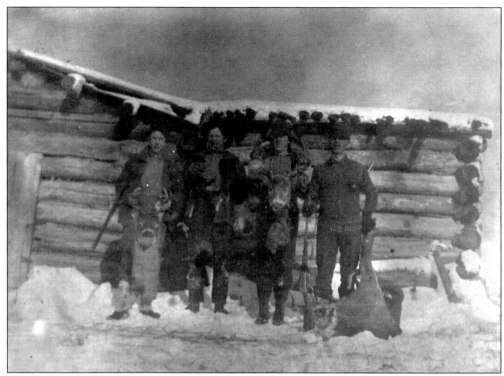

In 1906, the four Friesendahl boys posed for their dad, John, at their Crooked Creek camp. They had all escaped the fiery holocaust in Sandstone 12 years earlier. Along with their parents, two sisters, and a bucket of Swedish silverware, they "beat it to the river." After plunging into the current, they realized the bucket was more valuable than its heirloom contents and used it to dump water on their heads.

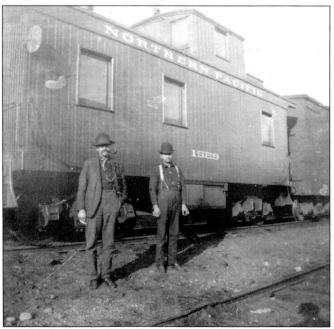

Jack Brennan, seen here at left in 1899, was working on the Eastern Minnesota railroad track near Sandstone on September 1, 1894. By noon, it was too dark to work, and speculations as to the sky's blackness included a solar eclipse and Hank Bowers's woodpiles burning. Later that afternoon, as the train backed into the depot, Brennan was the only person to board. He joined his mother and siblings, already in the caboose, and rode to Duluth.

John Grady Linehan (at right) moved from the Minneapolis metropolis to the pioneer town of Sandstone. He labored in the local quarry and at one time was employed to enforce the statutes in a rowdy town that included four saloons and two boardinghouses full of quarrymen and lumberjacks. He survived the conflagration in the Kettle River. In May 1906, he married fellow fire survivor Mary Agnes Jordan (below), who was 16 years his junior. Living in Hinckley and only six years old at the time, she eluded death by escaping with her family on the Eastern Minnesota train. The couple was married for 43 years and had a family of eight children. (At right, courtesy of Linda Troolin; below, Maureen DeMoss.)

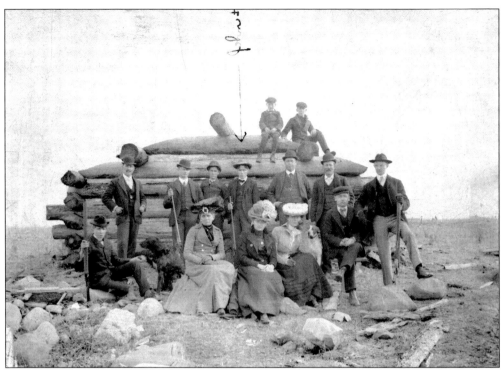

The desolation left behind after the fire is still visible in the background of this photograph of the Hawley hunting shack in 1898. Not much is visible that would attract any kind of wildlife for a hopeful hunter. John Hawley is in the middle of the group, identified by the arrow. (Courtesy of Annie Marczak.)

Holding his grandnephew James E. Larson in 1948 is Sandstone fire survivor John Flood Jr. His family sought refuge in their root cellar, emptying cans of milk upon themselves. Unable to bear the increasing heat, they ran to the Kettle River and shivered in the current until morning. After a 10-mile trek, all boarded a rescue train at Miller's Station. Upon returning home, the family dog was waiting to greet them. (Courtesy of James E. Larson.)

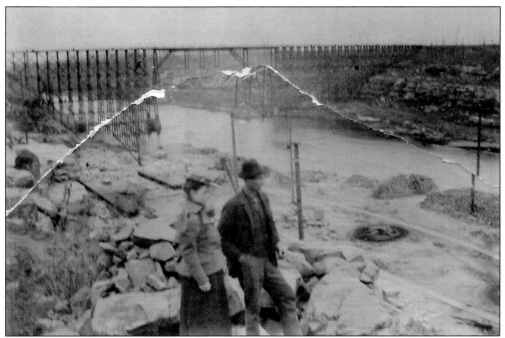

This railroad bridge spanned the Kettle River above the quarry in Sandstone for a magnificent 850 feet and stood 150 feet above the rushing waters. Engineers William Best and Edward Barry crossed the burning trestle backward with their combination train at four miles per hour. The structure collapsed into the river moments after the last car safely reached the eastern side.

Miller was originally a flag stop north of Hinckley on the St. Paul and Duluth Railroad. After the fire wiped the community off the map, the Koch Land Company encouraged Dutch immigrants to settle the area and rename it Groningen, the capital city in their homeland of Holland.

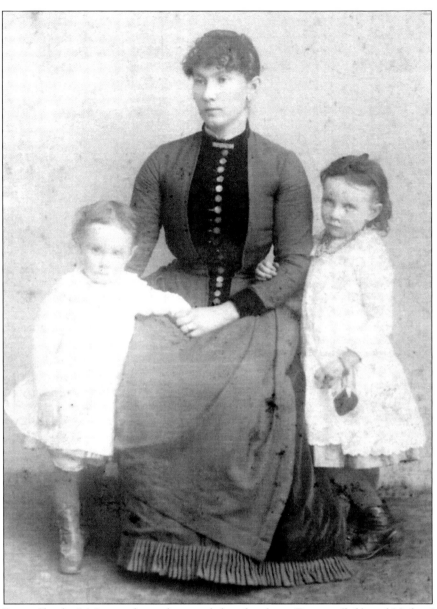

Mary Dunn Sheehy McIver is shown here with her daughters Frances (left) and Violet. Mary's second husband, Donald McIver, had moved his family to their Mission Creek farmstead in 1894 for the summer. Fearful of losing his crop, he had left earlier that day to check on some cut hay in a nearby lowland. As the fiery-red sky seemed to lower, his frightened wife and four children ran north, alternately hurrying through the smoke and then sinking to the ground in exhaustion. They continued for a mile and a half into town, catching the Eastern Minnesota train as it headed for Duluth. Her 25-year-old brother Thomas Dunn was the telegrapher at the St. Paul and Duluth station. The "lightning slinger" (an occupational nickname) received the news that Brook Park had burned, and he pounded the brass key to send along the information. As the depot roof caught fire, Dunn heroically manned his post to keep the lines of communication open. The last words he sent across the wire were, "I have stayed too long." His father identified his son's remains on September 2. McIver dodged the fiery disaster in Pelkey's swamp.

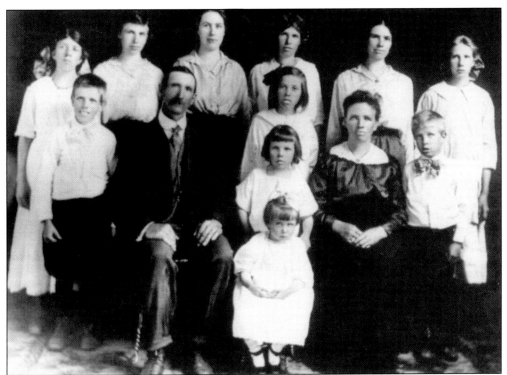

Adolph Anderson moved to Mission Creek just months before the fire that changed so many lives. On that day, his wife, Ellen, and daughters Esther and Edith were away visiting relatives. Residents of "Little Sweden" lived on cutover land and did not feel threatened by the small fires burning around them. The afternoon southbound train stopped, and no one boarded. An hour later, the villagers were running for their lives to a nearby potato patch. Covering each other with wet gunnysacks, they burrowed into the ground. After two long hours, they dug themselves out and gazed upon what was left of their settlement. A ramshackle cabin was still standing, while the sawmill and everything else was in ruins (below). The hungry survivors spied a deer caught in a fence, and this venison, along with potatoes dug from the earth that had sheltered them, was their evening meal. (Above, courtesy of Donna Anderson.)

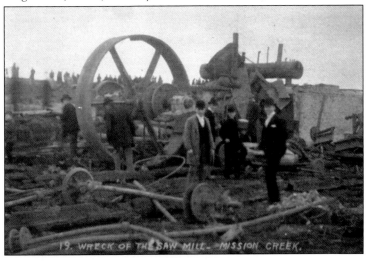

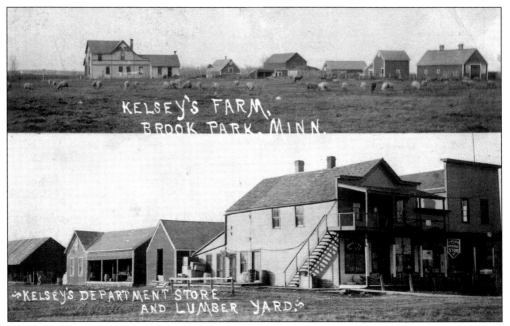

Brook Park was originally a railroad station referred to as Pokegama. The Kelsey and Markham Land Company christened it with a more agricultural sounding name in an attempt to attract potential buyers.

Dr. C.A. Kelsey was just a young man when he survived the fire in Pokegama. His family lowered themselves into their well, a strategy that did not bode well for most folks escaping the flames. Many victims were found suffocated in the bottom of their wells as the firestorm sucked the oxygen out as it passed over; however, the Kelseys waited out the firestorm while listening to their mother pray and sing hymns and fortunately survived. Pictured here in later years is Dr. Kelsey with his wife, Mabel.

The Oksanen family (pictured here) lived on Indian Lake, located on the western edge of the fire zone. Closer to Finlayson, the Cheney family huddled in their underground root cellar. They were slowly suffocating until a terrified donkey crashed through the cellar roof, creating enough ventilation for everyone to survive—including the donkey.

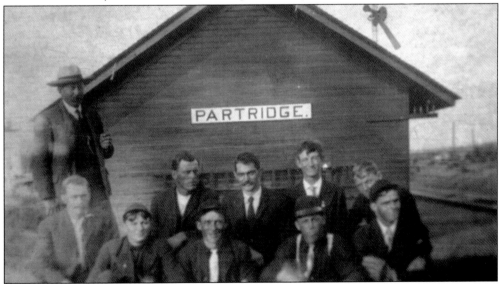

The 50 residents of Partridge, located six miles northeast of Sandstone, also passed on the opportunity to escape on the Duluth-bound train. A short time later, this collective error in judgement sent them fleeing northward on railroad handcars or plunging into a nearby lake. All that remained standing in the village was the water tank. The flames claimed the life of Robert Burns.

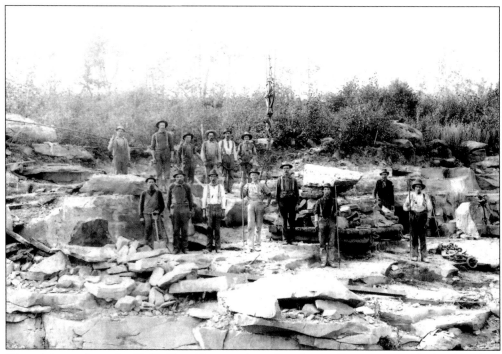

These laborers from the Hell's Gate Quarry, also referred to as Banning, were lucky that their boardinghouse escaped the flames. The Sandstone refugees were also lucky, for after trudging barefoot northward for five miles in the dark, they were relieved to find the shelter and a warm meal. After resting, they continued for another five miles—still shoeless—before reaching a rescue train at Miller. (Both courtesy of Ed Ness.)

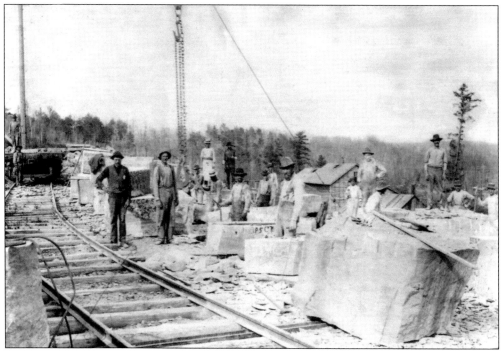

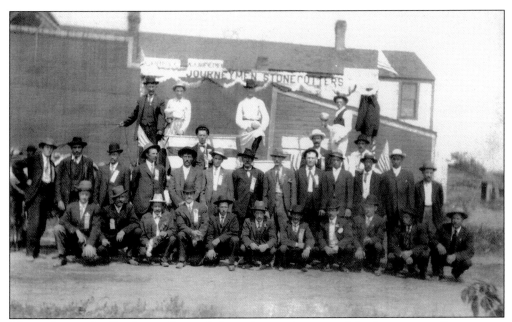

The workers at the Sandstone Quarry belonged to a union named the Journeyman Stonecutters Association of North America. This local chapter is preparing to march in a parade. Edwin Rodeen (the author's great-grandfather) is kneeling on the far left. (Courtesy of the Sandstone History and Art Center.)

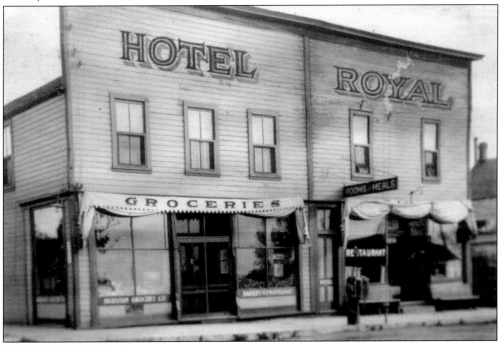

The Hotel Royal in Sandstone offered one-stop convenience for travelers. At its corner location, a patron could find lodging and a meal or head next door to get provisions at the Ingraham Grocery Company. Its tall false front with the name emblazoned on high directly faced the railroad depot.

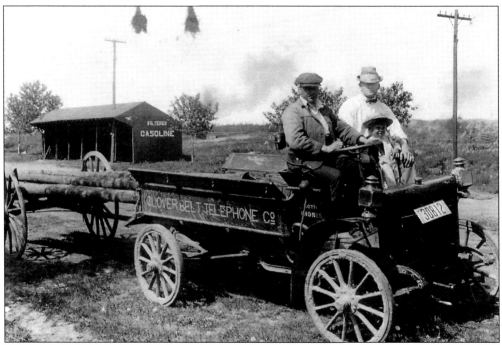

Local Sandstone businessmen invested in and organized their own telephone company. Hugo Wickstrom (left) was hired to manage the Cloverbelt Telephone Company in 1908. His son Harold is seated next to him. The man on the right is unidentified.

The southeastern edge of the fire zone extended into parts of Crosby Township, extinguishing itself before reaching the St. Croix River. In 1934, an initial 18,000 acres of this unscathed land was purchased by the State of Minnesota and designated a Recreational Demonstration Area. With improvements by the Civilian Conservation Corps and the Works Progress Administration, it opened in 1943 as St. Croix State Park, the largest state park in Minnesota.

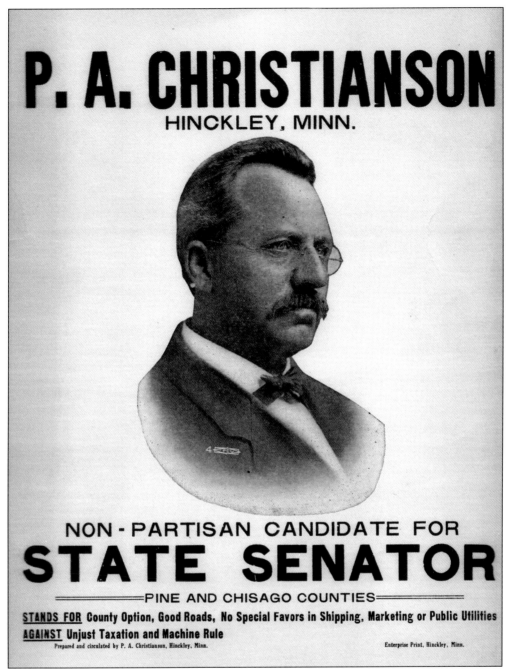

This local businessman was a mover and shaker in post-fire Hinckley. P.A. Christianson was involved in the lumberyard, the bank, real estate, copper mining, horticulture, and photography. He was also interested in local history, and the Christianson family collection was donated to the Hinckley Fire Museum. His senatorial candidacy was unsuccessful.

Snow time has always been fun time in Minnesota, at least for children. David Christianson (left) and the Gould brothers, Bob (center) and Leon, are giving a lucky toddler a ride in their homemade dogsled.

The ravaging flames exacted a great toll on the Edstrom family in Sandstone. The official death list includes five members of the household. Not on the list, but still a victim, is the young man pictured here on the left, Erick, in 1893. He survived that day but succumbed to his fire-related injuries the following year.

Eight

In Memoriam

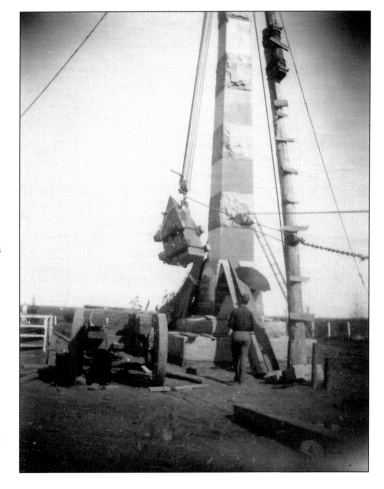

The townspeople of Hinckley agreed that a magnificent monument should be erected to honor the memory of its citizens who perished on that awful day. A bill was introduced by fire survivor and county attorney R.C. Saunders requesting funds for construction from the state legislature. Rep. T.H. McKusick presented the bill. After some opposition, the State of Minnesota appropriated $2,500 to the local monument committee.

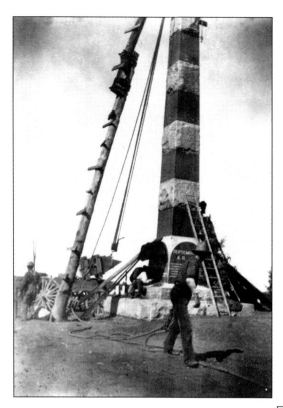

The building contract was awarded to the Arnold Granite Company of St. Cloud, Minnesota. This decision was upsetting to the neighboring town of Sandstone, which was also rebuilding after the fire. Sandstone's quarry had produced fine building material for structures and monuments all across the country, and its local newspaper *Pine County Courier* mused in print, "Why their fine sandstone wasn't good enough for Hinckley?"

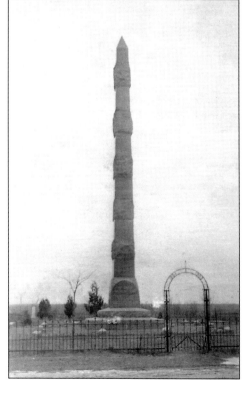

The monument to the victims of the Great Hinckley Fire was dedicated on September 1, 1900. It is 12 feet wide at the base, is 51 feet, nine inches tall, and weighs 60 tons.

Minnesota governor Adolph Olson Eberhart was a speaker at the 17th-annual fire memorial in 1911. He told the crowd that it was good for people of the whole state to stop once annually and remember the holocaust. He remarked that forest protection was better now than it ever was. He paid tribute to the men who had built up the new Hinckley and doubted that any place in the state could show as much progress in the past 17 years. Note the cornerstones marking the unidentified graves at the Lutheran Memorial Cemetery. Governor Eberhart is the tall top-coated man on the left in the first row. To the right of him are Howard Folsom and Joe Thierren. The man wearing a hat is fire survivor J.K. Anderson, and fellow survivor August Holm is to the right of him with an unfurled umbrella.

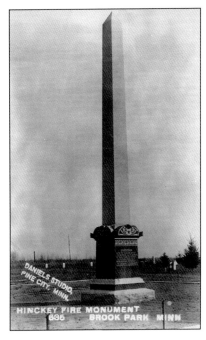

The State of Minnesota erected this monument to honor the pioneers of Brook Park (formerly Pokegama) who perished in the fire. The structure arrived via railroad flatcar. It took teamster Chris Slade two trips with his new lumber wagon and three teams of horses to haul the granite shaft a mile and a quarter to the local cemetery, which contains 23 victims of the fire in two trenches. The monument was dedicated on October 1, 1915.

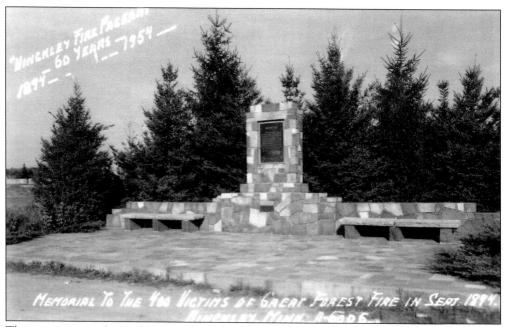

This monument is located just north of Hinckley on Old Highway 61. It marks the location of the "death swamp," where over 100 people perished.

The 55th anniversary of the fire was commemorated with a specially cacheted envelope. That year coincided with the 100th anniversary of the founding of the Minnesota Territory. Note that the centennial stamp is postmarked from Hinckley, Minnesota, on September 1, 1949.

Dr. E.L. Stephan, a hero of the Great Hinckley Fire (see page 49), was honored as grand marshal at the annual parade in 1949. (Both courtesy of Robert Peterson.)

In 1954, on the 60th anniversary of the fire, an outdoor pageant was held. The committee commissioned a playwright to compose a reenactment of that day, which was performed with local talent. The ceremony also included fireworks and Miss Susan Jensen as the "Spirit of Hinckley" (holding torch). (Courtesy of Robert Peterson.)

The residents of Hinckley who lived through the tragedy of September 1 organized officially as The Hinckley Fire Survivors' Association. The group met annually, many traveling great distances to attend. (Courtesy of Robert Peterson.)

Remembering the dead at the 1961 memorial observance at Lutheran Memorial Cemetery in Hinckley are the oldest living survivor, Charles Lundin (left), and the youngest, Frank Patrick. They are standing just inside the chain that encircles the four trenches where the unidentified remains of 248 men, women, and children are buried. The Paulson tombstone honors the family of Hans and Matilda, who perished that day along with their four children.

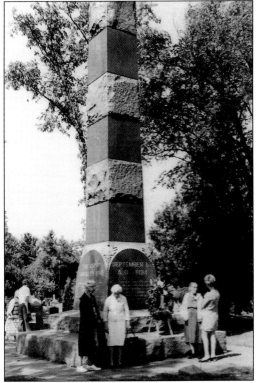

A memorial wreath was laid at the base of the monument in 1969 to commemorate the 75th anniversary of the fire. Seen here from left to right, facing the camera, are fire survivors Dora Williams Von Rueden, Johanna Peterson Lundin, Mary Anderson Kofoed, and unidentified.

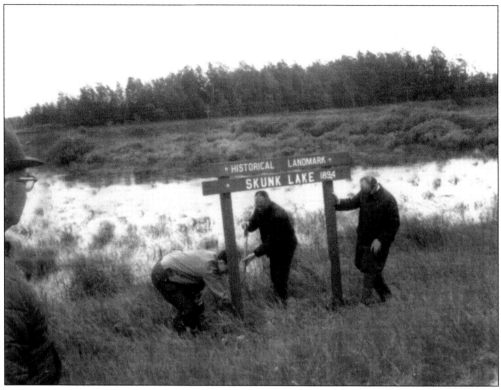

Members of the Pine County Historical Society install a marker at the infamous Skunk Lake. Hundreds of lives were saved that day in the swampy water. (Courtesy of Pine County Historical Society.)

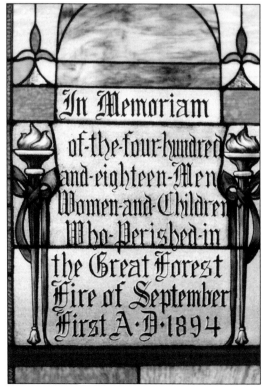

This stunning stained-glass window is a multicolored memorial displayed at the First Presbyterian Church in Hinckley. The congregation lost 25 members that day. (Courtesy of First Presbyterian Church of Hinckley.)

The vacant St. Paul and Duluth Railroad depot was restored by a hardworking group of local citizens. It opened as the Hinckley Fire Museum on July 4, 1976, as part of the United States' bicentennial celebration.

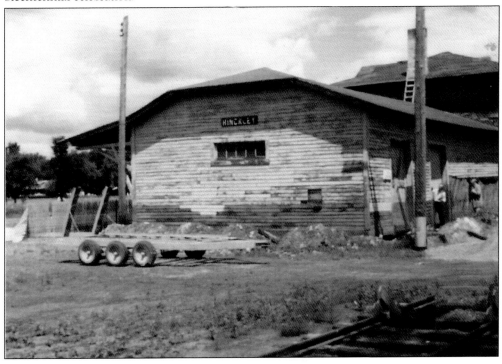

Fire survivor Johanna Peterson Lundin is escorted by Kon Bergum (left) and Clarence Wicklund (right). She was privileged to cut the ribbon at the grand opening of the Hinckley Fire Museum in 1976.

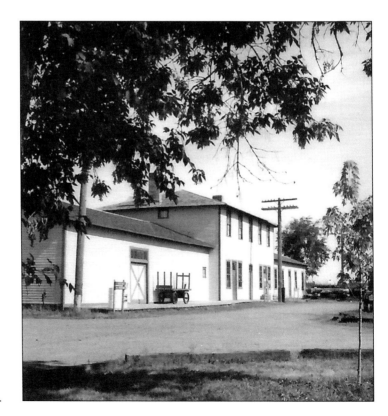

In 1973, the depot was added to the National Register of Historic Places. This is how the building looked after five years of restoration.

Pat O'Donovan is a Hinckley resident and a descendant of fire survivors Joe and Jane Tew. As part of the 100th anniversary commemoration, markers were placed to identify the few remaining original relief houses in town. (Courtesy of Linda Troolin.)

The gazebo visible on the right side of this photograph was constructed by John Stanchfield, a fire survivor and carpenter who literally helped rebuild Hinckley after the fire. The granite shaft stands steadfast in Lutheran Memorial Cemetery after recent repairs and remains a silent tribute to the town's pioneers.

In observation of the Minnesota state sesquicentennial in 2005, a replica of a No. 1 relief house was constructed by a special fire museum committee. It was furnished with the same basic items the survivors received: table and chairs for four, dinnerware, bed and bedding, heating stove, dry sink, cookstove and cookware, and a pail. It stands just south of the fire museum in Hinckley. (Courtesy of Al Wolter.)

Nine
EVERYBODY COMES FROM SOMEWHERE

The most historic eating place in Hinckley was established in 1871 and was located in the St. Paul and Duluth railroad depot. Early travelers nicknamed the café the "Beanery," and it was the original 24-hour fast-food establishment. Fire survivor Mary Anderson waitressed there in 1895. She recalled how the beans were baked in a large crock with the skin of a ham covering them. Pictured here is another fire survivor, Jane Tew Robinson, ready to serve customers on the next incoming train. The café survived many ownership changes, but the decrease in passenger train traffic forced it to close its doors in 1962.

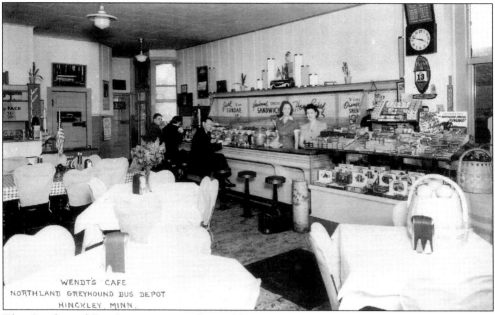

The Greyhound Bus Lines originated in Hibbing, Minnesota. As bus travel became popular, Hinckley became even more well known as the halfway stop between the Twin Ports (Duluth and Superior, Wisconsin) and the Twin Cities (Minneapolis and St. Paul). Fire survivor Anna Anderson Wendt and her husband, Isadore, operated their café for over 20 years. Waiting for the next 1940s-era bus to roll in are waitresses Maxine Brown (left) and Lena Rappe.

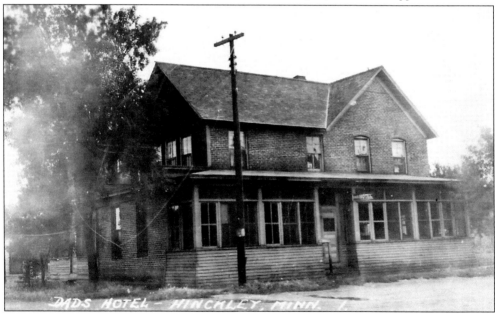

The gravel pit saved the life of Fannie "Ma" Coffin, who later operated the Coffin Hotel shown here. It was located on the east side of town by the Great Northern Railroad tracks. She served a chicken dinner that earned her a nationwide following among traveling salesman. Despite her gloomy surname, this lady was well known for her readiness to help a worthy cause. This brick building still stands in Hinckley, just south of the high school.

Tobie's Café was open 24 hours a day, offering coffee and comfort food to road-weary travelers. This original location was at the corner of Main Street and Highway 61 in Hinckley. When Interstate Highway 35 was completed east of town in the 1960s, many businesses, including Tobie's, left their downtown locations and moved to accommodate the freeway traffic. The restaurant still prospers and has become famous for the cinnamon rolls that its bakery produces. (Courtesy of Tobie's Restaurant.)

Cassidy's Café began business in Hinckley around 1922. It was owned and operated by Frank and "Ma" Cassidy, who also rented rooms above the restaurant. Local businessmen would come in every morning to drink coffee and consume the day-old sweet rolls, becoming affectionately known by Ma as "nickelers." It was one of the favorite places for the "ladies who lunch," both downtown and later at its freeway location.

This curly headed toddler grew into one of the toughest football players in history. Ernest Alonzo Nevers was the sixth son of George Nevers (see page 47) and born in 1902, eight years after his family survived the Great Hinckley Fire. While playing for the Chicago Cardinals in 1929, Ernie scored 40 points in one game, a record that is still unbroken. Nevers was a charter member of the Pro Football Hall of Fame. (Courtesy of Rose Mielke.)

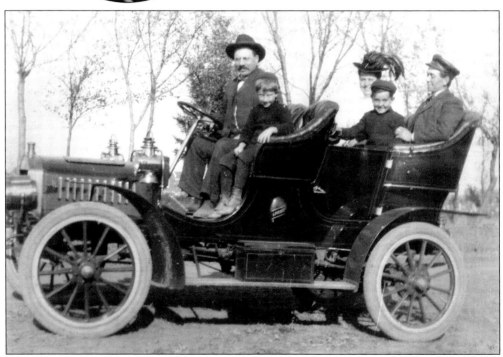

Behind the wheel of this 1909 two-cylinder Luverne is P.A. Christianson, a pioneering businessman who moved to Hinckley in 1903. It is one of only 300 cars ever manufactured by the southwestern Minnesota automobile company. It sold for under $2,800 at the time. The automobile's body was made entirely of wood. Along for the ride are the driver's son David and the car's co-inventor, Al Leicher and his family.

In 1897, a son was born to the family of Hinckley attorney R.C. Saunders in their relief house on the west side of town. John Monk Saunders became a Rhodes scholar, World War I veteran, and a motion picture screenwriter. He penned the script for a silent film entitled *Wings*, which won the first Academy Award for Best Picture in 1927. It starred the *It* girl Clara Bow and newcomer Gary Cooper.

The smiling man in the center of this photograph is Charles Harold "Happy" O'Malley. The tall gentleman on the left is fellow Minnesotan Charles Lindbergh Jr. This image was probably taken at the US Army Air Force training base in Texas during World War I. The instructor would run alongside the single-seat training plane and shout directions at the student in the cockpit (note the megaphone). The man on the right is an unidentified mechanic. Lindbergh was the first pilot to achieve a solo transatlantic crossing in 1927. O'Malley returned to Hinckley and operated a dance hall named Happy's Pavilion. It was a Saturday night hot spot for many years.

Shown here is Bob Ludwig of Duxbury, Minnesota, with the mounted deer head that he purchased second-hand for $3. After official scoring by Boone and Crockett in 1965, the antlers became the new world record for a typical whitetail deer, a mark that lasted until 1993. An investigation determined that fire survivor Jim Jordan had harvested the trophy in Wisconsin in 1914. Jordan passed away in October of 1978 and was posthumously awarded the record two months later. (Courtesy of Bob Ludwig.)

Everyone in Minnesota likes to go "up north" for rest and relaxation. Taking it easy on the shore of Grindstone Lake is Dr. Arnold Schwyzer and his wife in the early 1900s. He was a contemporary of the Mayo brothers. Note the damage from the Hinckley fire still visible in the background. Schwyzer's former recreational property is currently home to the Audubon Center of the North Woods, an environmental learning retreat. (Courtesy of the Wiberg family.)

This adorable baby girl is Leona May Merritt, daughter of Alfred and Olive. The Merritt family is credited with the discovery of iron ore in northern Minnesota. Leona was the first white child born in Mountain Iron, Minnesota. She later married and moved to her husband's farm in the Hinckley area and raised a minister, a schoolteacher, and a doctor's assistant. (Courtesy of the Koksma family.)

This one-of-a-kind snow machine was fabricated around 1954 by Hinckley residents Chet Maser and Don Dupree. It was a custom order from Dorothy Molter, proclaimed by *Life* magazine as "the loneliest woman in the world." Molter was the last non-indigenous resident of the Boundary Waters Canoe Area near Ely, Minnesota, and locally famous for the homemade root beer she sold to thousands of canoeists passing by her fishing resort. (Courtesy of Deanna Maser Cabak.)

Irishman Michael Cassius Dean endured the afternoon of September 1 by immersing himself in the Grindstone River that flowed by his farm a mile east of Hinckley. Remarkably, his newly constructed house defied the flames, and they both survived. In 1922, Dean self-published a now historical collection of 167 folk songs that he had learned in lumber camps and sailing on the Great Lakes. Despite extensive research, a photograph of Dean has never been located. (Courtesy of Brian Miller.)

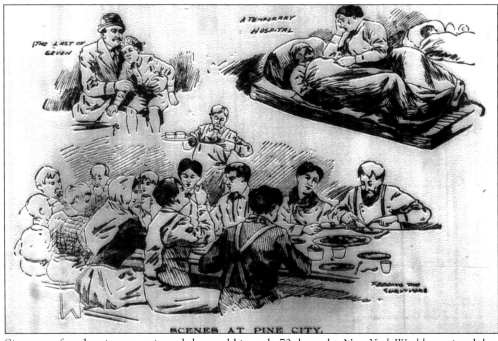

Six years after she circumnavigated the world in only 72 days, the *New York World* sent its globe-trotting girl reporter Nellie Bly to cover the story of the Great Hinckley Fire. These sketches accompanied her story, published on September 7, 1894.

This studious-looking man was a soldier in the search party that tracked President Lincoln assassin John Wilkes Booth in 1865. Sgt. "Boston" Tom Corbett gained fame after claiming credit for the killing shot. By 1887, he had been committed to, and escaped from, an insane asylum. During the early 1890s, an old character named Tom Corbett became known in Pine County as a prolific hunter, supplying local logging camps. He was never seen again after September 1, 1894. (Courtesy of the National Archives.)

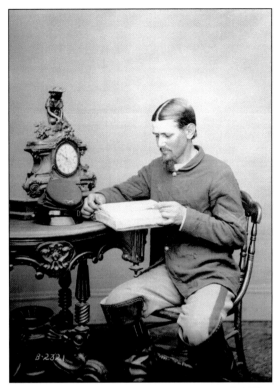

Americans will never forget the sinking of the USS *Arizona* during World War II. The last man to leave the ship was a young sailor named Alvin Dvorak, who resided near Hinckley while growing up. Dvorak suffered from burns over 82 percent of his body and succumbed to his injuries on December 24, 1941. A search for a photograph of this Navy hero has been fruitless. (Courtesy of Lauren Brunner.)

Discover Thousands of Local History Books
Featuring Millions of Vintage Images

Arcadia Publishing, the leading local history publisher in the United States, is committed to making history accessible and meaningful through publishing books that celebrate and preserve the heritage of America's people and places.

Find more books like this at
www.arcadiapublishing.com

Search for your hometown history, your old stomping grounds, and even your favorite sports team.

Consistent with our mission to preserve history on a local level, this book was printed in South Carolina on American-made paper and manufactured entirely in the United States. Products carrying the accredited Forest Stewardship Council (FSC) label are printed on 100 percent FSC-certified paper.